THEN & NOW

WINSTON-SALEM

OPPOSITE: Wagons and automobiles, loaded with tobacco and covered with blankets, could only mean one thing in the early days of Winston-Salem—it was time for the tobacco market. The lines formed early on North Main Street in front of Brown's Tobacco Warehouse and continued as far as the eye could see. Boardinghouses, restaurants, livery stables, hardware stores, and food markets are a few of the local businesses that benefited from a prosperous tobacco growing and auction season. (Courtesy of Forsyth County Public Library [FCPL].)

THEN *&* NOW

WINSTON-SALEM

Molly Grogan Rawls

Molly Grogan Rawls

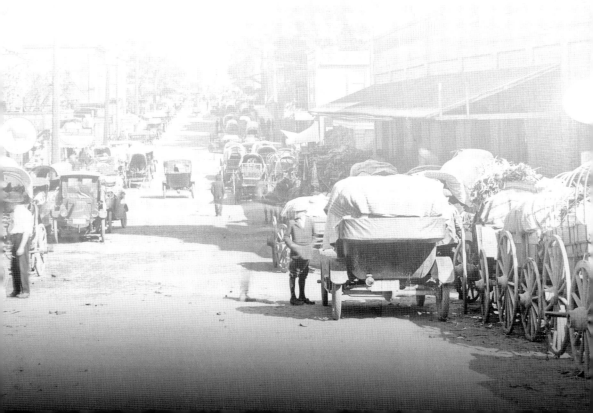

This book is dedicated to the good memories of Winston-Salem's past, to the good times happening there today, and to the good people who call Winston-Salem home.

Published by Arcadia Publishing
Charleston SC, Chicago IL, Portsmouth NH, San Francisco CA

Printed in the United States of America

For all general information contact Arcadia Publishing at:
Telephone 843-853-2070
Fax 843-853-0044
E-mail sales@arcadiapublishing.com
For customer service and orders:
Toll-Free 1-888-313-2665

Visit us on the Internet at www.arcadiapublishing.com

ON THE FRONT COVER: After Winston and Salem officially joined in 1913 to become Winston-Salem, they also consolidated their government affairs and built a new city hall in 1926. Northup and O'Brien, a local architectural firm, designed the three-story Renaissance Revival building shown at right in both images. Looking north on Main Street at First Street, the Reynolds Building can be seen in the distance in the 1951 image, but it is barely visible today behind the Winston Tower and the Federal Building. (Then image courtesy of FCPL; Now image courtesy of the author.)

ON THE BACK COVER: The Belk-Stevens department store on the corner of Trade and Fifth Streets was a shopping destination for many years in downtown Winston-Salem. After Belk moved to Hanes Mall in 1975, the Belk building and others in the block were slated for demolition to accommodate a new hotel nearby. As surrounding buildings became piles of rubble, the previously hidden facade gave a historical reminder that this structure once housed the Huntley-Hill-Stockton Furniture Company and its companion business, a funeral parlor. (Courtesy of FCPL.)

CONTENTS

ACKNOWLEDGMENTS

It's hard to get your arms around the many facets of a city's history, so it helps when family, friends, and even complete strangers offer their assistance by adding length and strength to your arms. This book would not have been possible without the contribution and participation of many individuals who so willingly shared their knowledge of Winston-Salem history, their photographs that show how the city looked and how it has changed, and their expertise in preparing these photographs for publication.

I am fortunate to have talented family members who are willing to lend their expertise to my projects. My husband, Jeffrey, helped select the historic images for the book. His skill and patience in preparing the photographs for publication was invaluable. Jeffrey and I photographed all the current locations unless otherwise noted in the captions. My son Curtis assisted in making the images presentable for publication. My son Allen helped with programming software for historical documentation. My son Kevin designed and produced my Web site, www.mollygroganrawls.com. My brother John H. Grogan photographed several downtown locations (pages 17 and 47) and captured the area surrounding Reynolda Manor Shopping Center in the aerial shot (page 77). My parents, Joseph C. Grogan Sr. and Angelia Mackie Grogan, read my manuscript and offered helpful comments.

Several individuals and corporations allowed me to use their historic and current photographs in the book. Gordon H. Schenck Jr. photographed Reynolda Manor Shopping Center (page 77) when it opened in 1963 and remembered this as an early assignment in his photography career. Annette Wagoner of Quality Oil Company allowed me to view their photographic archives, from which I selected the Staley's Restaurant photograph (page 63) for the book. Chris Timmons, owner of Bo's Photography, made our family portrait (page 93) and granted permission to use it in the book.

When I visited current sites and took photographs, I often received valuable assistance from the professional staff members, such as those at Brookridge Retirement Community and Salemtowne, who provided informative historical background and current materials on their facilities. The historic images, unless otherwise noted, came from the Forsyth County Public Library (FCPL), where I work as photograph collection librarian in the North Carolina Room.

I also appreciate the suggestions made by a host of acquaintances who answered my question, "What would you like to see in a Then and Now book about Winston-Salem?" I hope that readers will see photographs of their favorite places and that the book will recall good memories of Winston-Salem.

INTRODUCTION

Winston-Salem—two towns and two identities joined by a hyphen in 1913 to become one city—is a marriage that has lasted 95 years and counting. Like all good marriages, the partners have experienced and weathered the excitement, challenge, and benefits that come with building and sustaining a relationship.

Winston-Salem is the county seat of Forsyth County, which was established in 1849 from the southern part of Stokes County. Forsyth County is located in the Piedmont section of North Carolina, close to the Virginia state line. From Winston-Salem, travelers can drive west to the mountains or east to the coast, all the while remaining in North Carolina. State residents experience four distinct seasons, from warm springs with beautiful flowers and trees, to hot and humid summers, to colorful and brisk autumns, to cold and sometimes snowy winters.

The town of Winston was established in 1849 and named in honor of Joseph Winston, a Revolutionary War hero and a state senator from Stokes County. The Moravians settled Salem, which means "peace," in 1766. Salem was the third Moravian settlement in Forsyth County, after Bethabara (1753) and Bethania (1759). The Moravians sold the land on which the first Forsyth County Courthouse and the town of Winston were built.

The early homes and businesses were built around the courthouse square in Winston. As the town grew, the town limits stretched to include new neighborhoods in the suburbs. Then businesses were established in these suburban areas, and the downtown felt the drain of shoppers and urban dwellers. Shopping centers and malls offered shoppers free parking and many retail opportunities in one location. While this phenomenon has forever changed our living and shopping habits, Winston-Salem has seen the slow but steady revival of interest in living, shopping, working, and dining in the downtown area.

The city has experienced its share of change, because active, vibrant cities are in a constant state of change. If you doubt this fact, just try to photograph buildings or street scenes for a book that you want to still be current by publication time. Buildings go up; buildings come down; businesses open; businesses move; businesses close. Then & Now: *Winston-Salem* gives the reader a glimpse at the city as it looks in 2008, paired with photographs that show how it has looked at various times throughout its history.

So get comfortable for a ride down memory lane and see what's been happening in Winston-Salem.

GOING DOWNTOWN

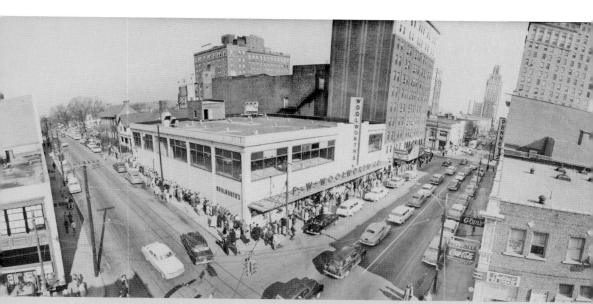

Moviegoers line the block at Fourth and Spruce Streets in 1956 to reach the Carolina Theatre and get a glimpse of Elizabeth Taylor, Rock Hudson, and James Dean in *Giant*. The F. W. Woolworth store opened in 1955, replacing three stores and the Forsyth Theatre. The Carolina Theatre was refurbished as the Stevens Center and today hosts a full schedule of entertainment choices.

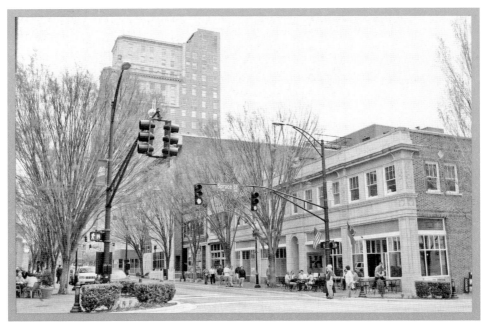

Across from the Carolina Theatre and F. W. Woolworth Company, the block that housed J. C. Penney, L. Roberts, Recreation Billiards, Byerly and Steele, Glyn's, and Carolina Drugs gave shoppers many choices in 1956. Today these buildings are intact, but only Recreation Billiards exists as a business. The original pool hall opened in 1947 and was revamped in 2006, after several blocks of Fourth Street received wider sidewalks and trees that shade outside diners on both sides of the street.

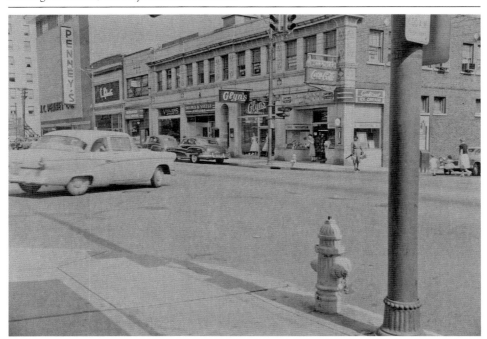

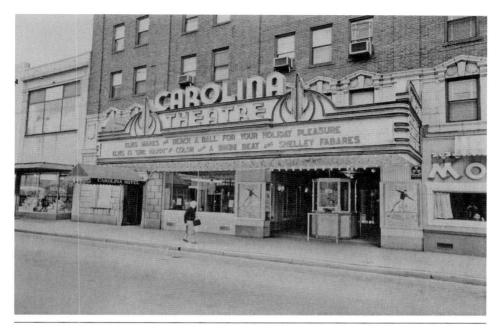

"A most remarkable young man named Elvis Presley came to town yesterday and rocked the staid old Carolina Theatre to its very dignified roots." *Winston-Salem Journal* columnist Roy Thompson made this comment in 1956 when Elvis performed three shows before a crowd that was just beginning to appreciate the world of "rock 'n roll." The Carolina Theatre stage was host to hundreds of entertainers during its life, as is its refurbished counterpart, the Stevens Center, which opened in 1983.

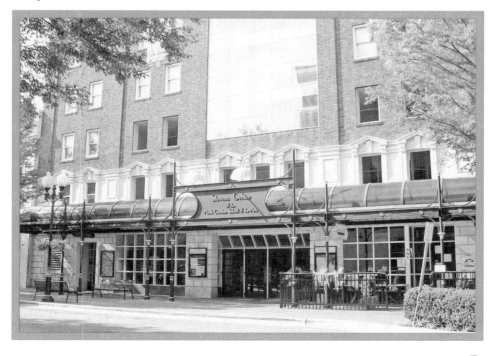

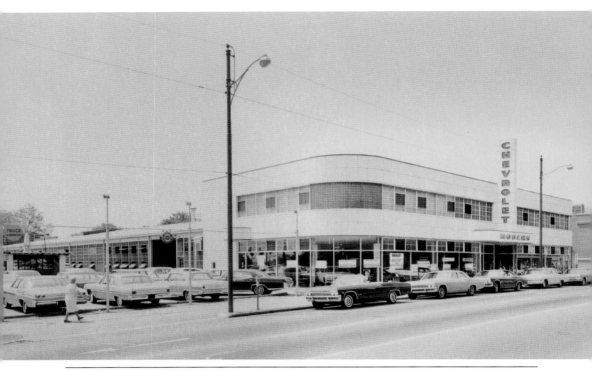

Founded in 1933 by O. T. Fowler and R. E. L. Morefield Sr., Modern Chevrolet was first located in rented space in the 100 block of North Main Street. The business moved into new quarters on West Fourth at Broad Streets in November 1947. The striking white International style building, designed by local architect Hall Crews, was demolished after the company moved to University Parkway in 2004. The condominium complex West End Village, with Caffé Prada on the street level, occupies the corner today.

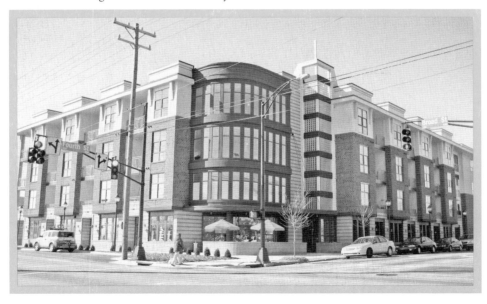

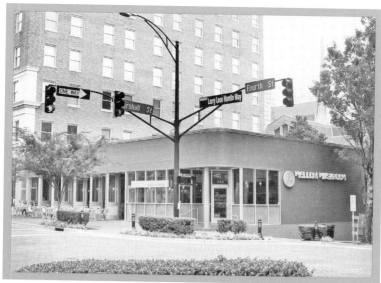

Parades always attracted a large crowd on the downtown streets, and this photograph shows a football parade at the intersection of West Fourth and Marshall Streets, complete with a marching band and cars decorated with crepe paper. The Mellow Mushroom restaurant opened on the southeast corner in 2006 in a uniquely designed building that allows the doors on the sidewalk to fold back to create more outside dining space in pleasant weather.

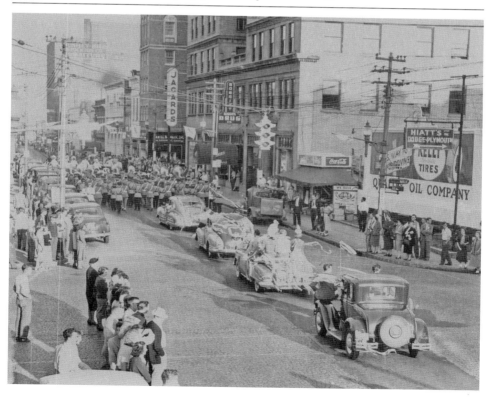

Artists, craftsmen, performers, and food preparers gather downtown in 1976 to hold the first Carolina Street Scene. Joseph Schlitz Brewing Company, the Arts Council, and other arts groups sponsored the two-day event dubbed "one of America's greatest street festivals" by the chairman of the board at Schlitz. Rock the Block revived the street festival concept in 2002 to celebrate Fourth Street's new look of wider sidewalks with newly planted trees. The 2007 event celebrated with music, dancing, and food, ending the 10th season of downtown summer concerts.

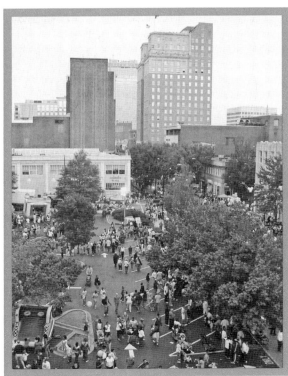

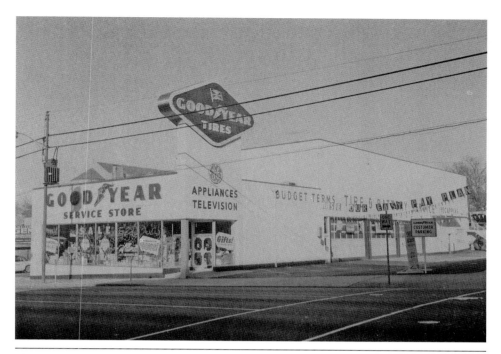

The Goodyear blimp flew for 12 days in 1960 over the new Goodyear store on the corner of West Fourth and Poplar Streets. Appliances, bicycles, and home and auto accessories were displayed on the first-floor showroom. A tire shoot was installed on the second level so that any tires that were requested could be routed directly to the tire service area. The Chamber Building, housing the Winston-Salem Chamber of Commerce and a parking deck, currently occupies the site. (Now photograph by John H. Grogan.)

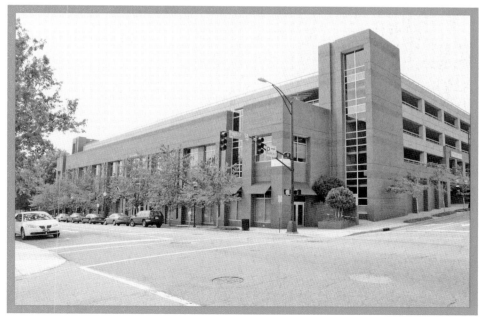

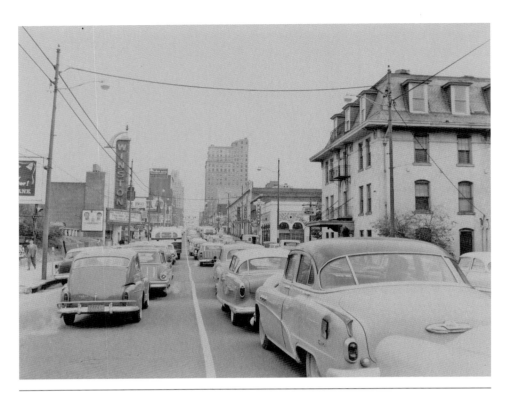

Driving downtown on this day in January 1960 required some patience, with the cars lined up on West Fourth Street near the Winston Theatre. The one-way traffic often slowed when special events or sales were taking place. The Winston Theatre was converted to office space in the early 1980s, and the neighboring restaurants, such as the Dutch Treat and Manuel's, gave way to other businesses. A parking deck, with a tower, was built across from the Winston Theatre.

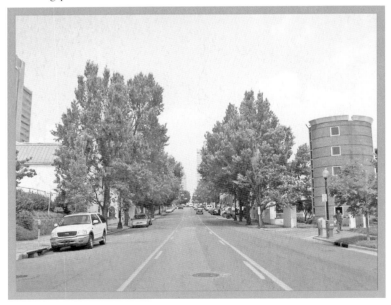

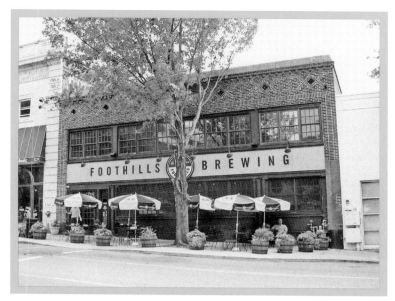

The building at 638 West Fourth Street was involved with automobiles from the very beginning. The business that was previously named Auto Repair and Sales became Bowen-Matthews Motors and then became Odell Matthews Motors in 1957. Foothills Brewing opened in 2004 and offers a combined restaurant and brewery in the restored 1920s building, which features tall ceilings and hardwood floors. Diners can watch the brewing process and enjoy the live entertainment or dine at the outside tables.

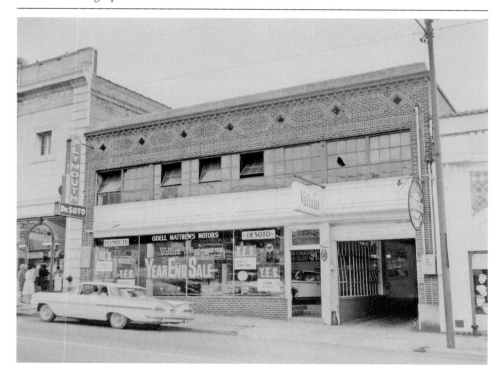

In Winston's early days, all of the town's business was conducted in one building, with room to spare for a city market, a telephone exchange, and an armory. Located on the corner of Main and Fourth Streets, town hall was auctioned in 1927, and its Seth Thomas clock was sold to Calvary Moravian Church. R. J. Reynolds Tobacco Company constructed its new office building on this site in 1929 and continues to conduct its business from this 401 North Main Street address.

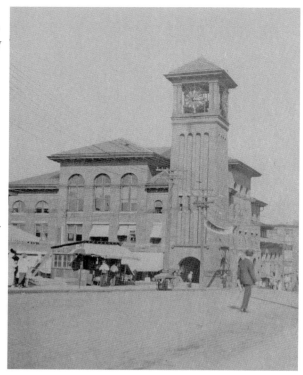

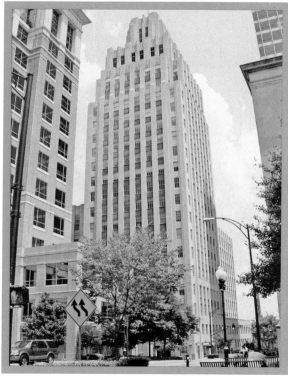

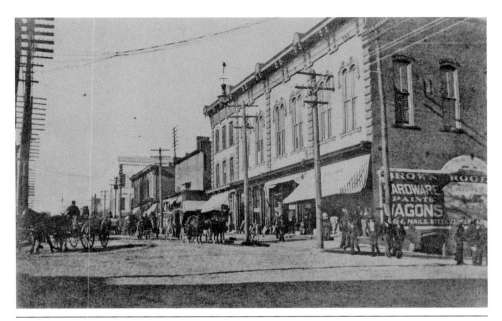

The corner of West Fourth and Main Streets was occupied in the early 1900s by F. C. Brown, a general merchandise store. Its neighbor to the west was Brown, Rogers, and Company, which sold stoves, ranges, furnaces, sheet-iron heaters, glass, paints, oil varnishes, and other items needed to maintain one's home. Many businesses occupied this block before it was leveled and the One West Fourth Street building (below, at right) was constructed in 2002. The O'Hanlon Building, rebuilt in 1915 after a fire, can be seen (below, at left) in the background.

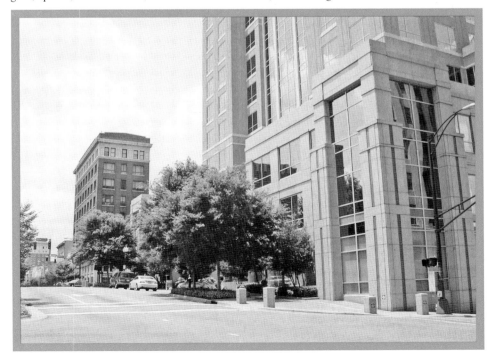

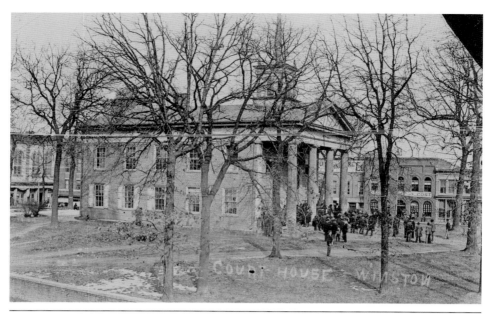

Forsyth County was formed in 1849 from Stokes County, and the first courthouse (above) opened in 1850 on land surrounded by Main, Fourth, Liberty, and Third Streets. Businesses vied for the prime locations around the courthouse square, and citizens regularly congregated there to discuss events of the day. The first courthouse was demolished and the second courthouse (below) opened in 1897, designed by architect Frank Milburn. Built of granite, buff brick, and brownstone, the new courthouse featured a bell tower.

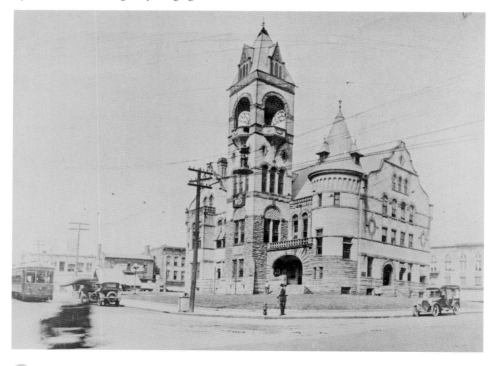

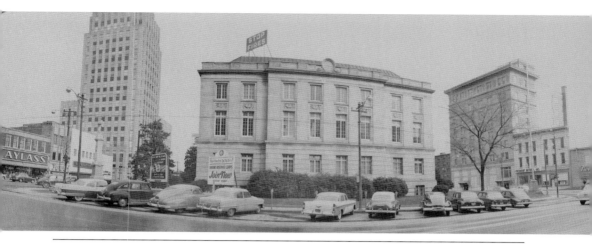

The third Forsyth County Courthouse (above, center) resulted from a face lift to the 1897 building in which the main entrance was moved from Liberty to Third Street. The enlarged and renovated building opened in 1927 with a new look for the courthouse square. Another change in appearance (below) took place when the wings were added in 1960, totally consuming the courthouse square. After a new Hall of Justice was built in 1971, the building was used for a variety of purposes before being vacated.

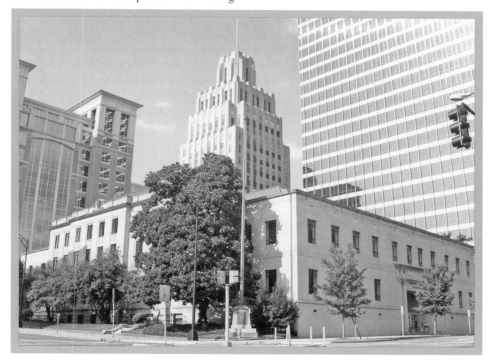

Summit School was founded in 1933 by parents concerned about the overcrowded conditions in the public schools. Louise Futrell, one of the founders and the first principal of the school, is shown at left with Barbour Strickland in front of the 405 Summit Street house where the school first met. A new school building was occupied in 1946 at Reynolda Road, where additions have been made to the building over the years. Summit School students and alumni celebrate the school's 75th anniversary in 2008.

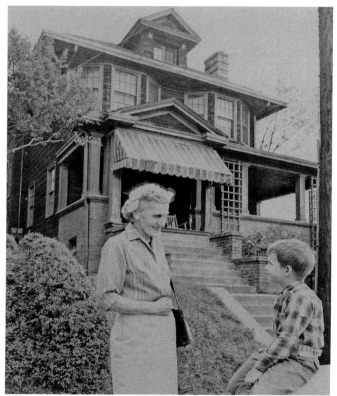

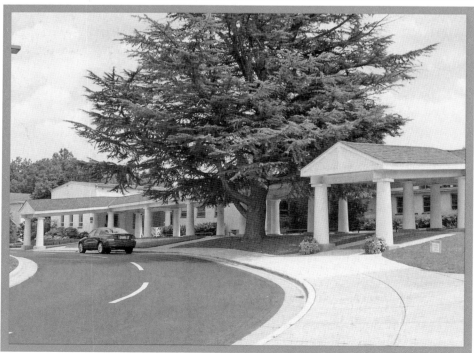

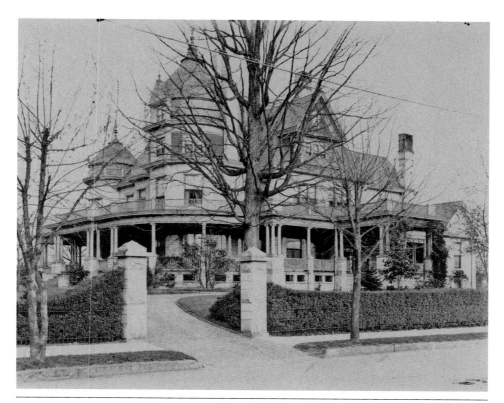

Richard Joshua Reynolds and his wife, Katherine Smith Reynolds, lived in this elegant home at 654 West Fifth Street with their four children until they moved to their new home on Reynolda Road in 1917. The house was later demolished and the land was given in 1948 to the Winston-Salem Library Commission by Richard J. Reynolds Jr. The new Forsyth County Public Library opened at this location in 1953, and a 48,000-square-foot addition was built in 1980.

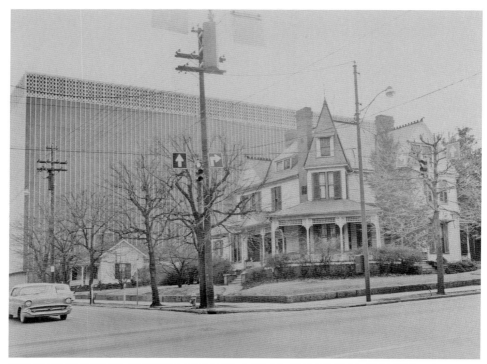

Henry Dalton Poindexter owned a mercantile store at 411 North Trade Street that sold everything from pins to mattresses. The large 19-room Victorian home, built in 1893 on the corner of Fifth and Spruce Streets, was home to Poindexter's large family. Their next-door neighbor, Security Life and Trust Company, grew from a seven-story building into the skyscraper that today houses GMAC Insurance. When the insurance business needed more land, the Poindexter house was relocated to a lot on West End Boulevard.

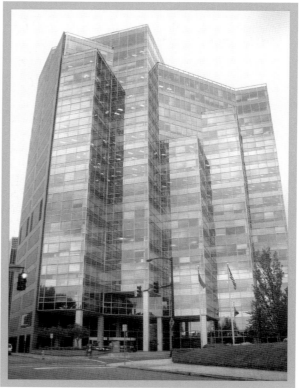

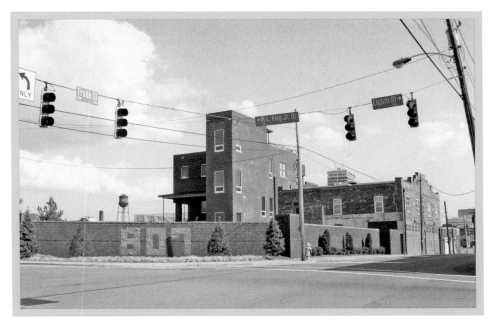

The buildings that sit atop the hill near the extension of Martin Luther King Drive, Eighth Street, and Trade Street bear no resemblance to the reservoir that once occupied this site and caused the city's worst disaster. On November 2, 1904, the north wall of Winston's brick-and-concrete reservoir collapsed, emptying 800,000 gallons of water into the street. Nine people were killed, several were injured, and many homes either collapsed or washed away, leaving rubble and mud in the flood's wake.

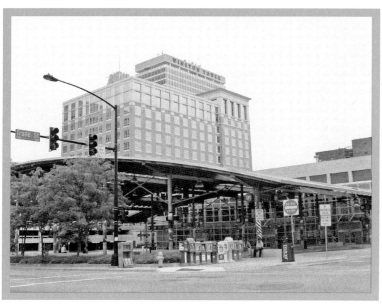

The 400 block of North Trade Street was bricked over to form a pedestrian mall in 1970. Businesses that existed on the mall during this 10-year period included Hinkles Book Store, Thom McAn shoe store, Eckerd's Drugs, and Hine Bagby. The Fifth Street businesses across from the post office and seen at left included Lindley Photo, Steve's Sandwich Shop, and N&J Sandwich Shop. This block of businesses was demolished in 1995, and the Winston-Salem Transit Center opened at this location in 1997.

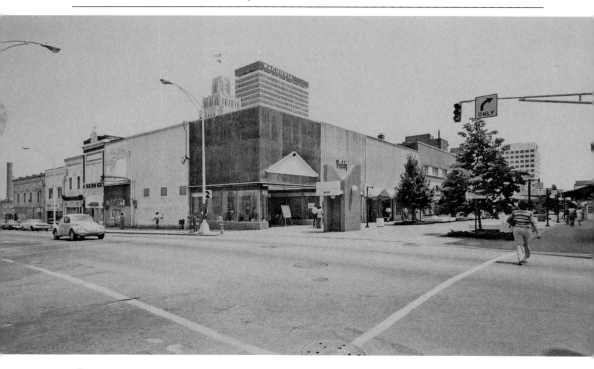

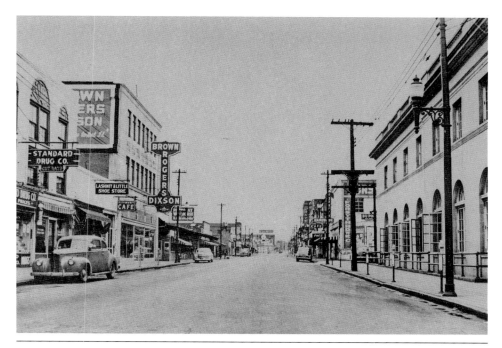

The 500 block of North Trade Street has always featured a mixture of businesses. The U.S. Post Office (at right) was next door to the Forsyth Hardware Company and across the street from Brown Rogers Dixson, the Piedmont Café, and a variety of small businesses. Tobacco warehouses, cafés, and a furniture store were located near the end of the block. A mixture of businesses currently occupies this block. Newcomers ISP Sports Marketing, Trader's Row, and Signature join established businesses to entice shoppers to see what's new on Trade Street.

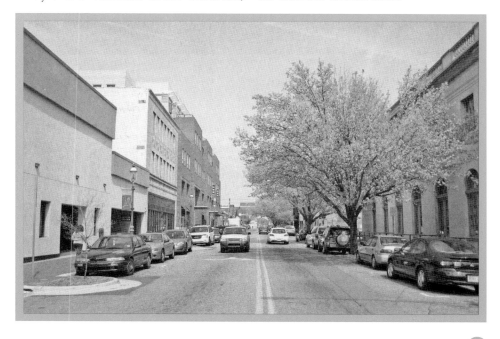

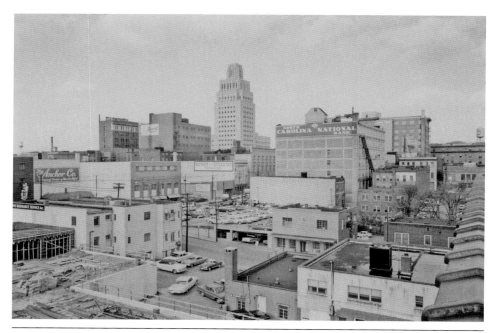

The Winston-Salem skyline, looking northeast in 1964, shows the Reynolds Building standing tall amid the surrounding buildings. The photograph shows the North Carolina National Bank, Mother and Daughter Fashions, and the Anchor Company, which are noticeably absent from the more recent photograph. Appearing in the current skyline is the sheriff's department administration building (white building), and flanking the Reynolds Building are One West Fourth Street and the Winston Tower.

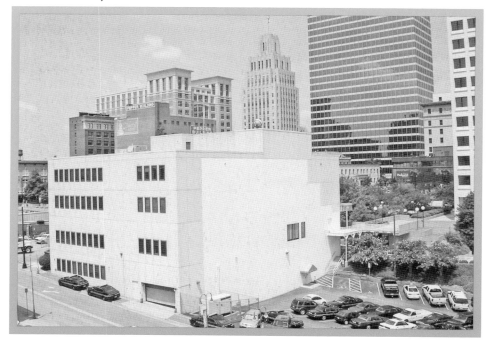

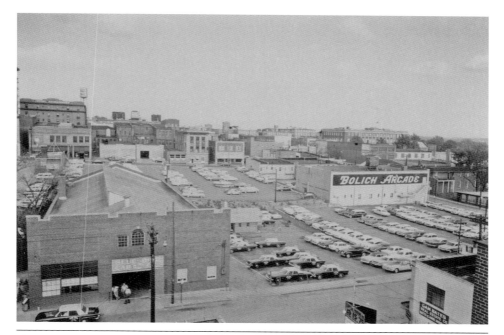

The companion skyline photograph, looking southeast in 1964, shows in the distance the block of Liberty Street businesses that were later demolished between Second and Third Streets. North Trade Street is at the bottom of the image, showing the Blue Bird Cab Company, Bolich Arcade, and a parking lot. In the current photograph, the Hall of Justice is the white building near the center, and the BB&T Tower is at right. North Trade Street was renamed Town Run Lane for this section of the street.

The bus station that opened on Cherry Street in 1942 was built on the site of Col. George Hinshaw's home and garden. The Union Bus Depot, shown here in 1963, was situated next to the K&W Cafeteria, down the street from the Robert E. Lee Hotel and a parking garage. The hotel, garage, cafeteria, and bus station were demolished in 1972. The Embassy Suites Hotel and a parking deck occupy this site today (at right), with a skywalk to the Marriott Hotel (at left).

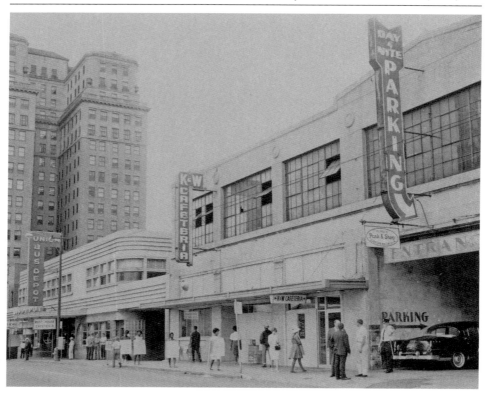

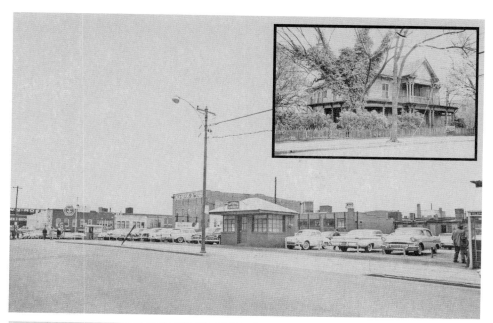

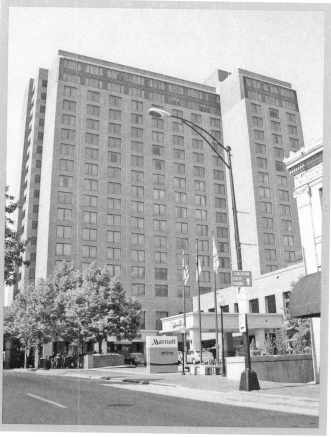

At the beginning of the 20th century, there were three Hanes families living in the 400 block of North Cherry Street. The Pleasant Henderson Hanes home (inset), situated in the center of the block and the last home standing, was demolished in 1948. The half of the block near West Fifth Street was cleared, paved, and used as a parking lot for many years. The Adams Mark Hotel was built here later, and then it was refurbished and opened as the Marriott Hotel in 2005.

Dr. John Henry Shelton and wife Ellen Belo Shelton were building a new home on Cherry Street when Dr. Shelton contracted typhoid fever and died in 1881. Ellen Shelton lived in her home on the corner of Cherry and First Streets until her death in 1912. The house featured a swimming pool in the side yard. Later residents included Hugh G. Chatham and the Winston-Salem Chamber of Commerce. Century Plaza, a multiuse office building, was built on the corner in 2001.

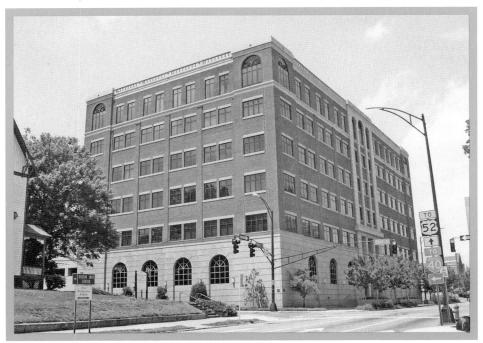

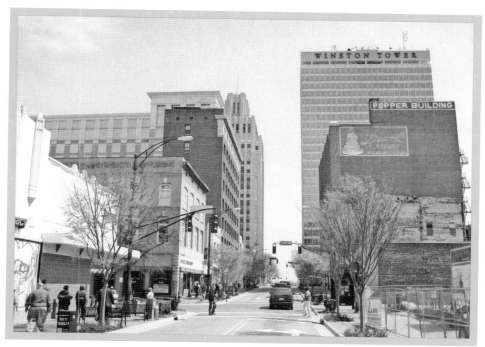

Streetcars carried townspeople from one end of town to the other in the days before automobiles appeared on the city streets. In the 1911 Then photograph, West Fourth Street is shown looking east toward Trade Street. The Masonic Temple is the tall building at left, with town hall and its clock tower in the distance. Of all the buildings in this view, only the three-story building at the northeast corner of Trade Street is standing in the current photograph, reflecting the changes over nearly 100 years.

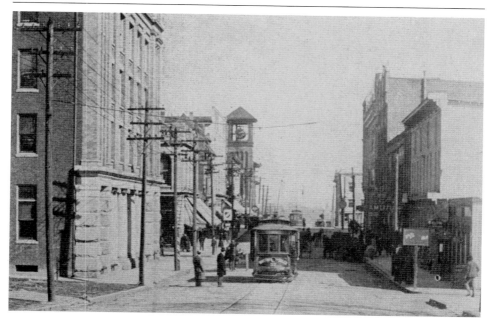

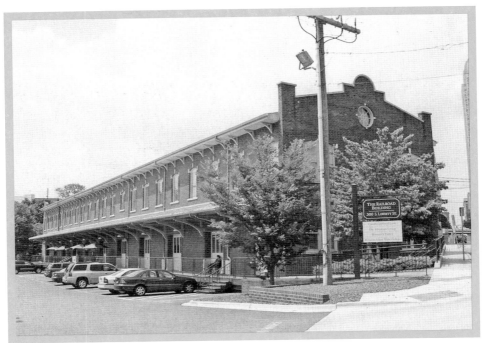

The F&H Fries Woolen Mill was located on South Liberty Street near Shallowford Street, which is now called Brookstown Avenue. The mill was one of Salem's earliest industries and was replaced about 1913 by the freight station and yards for the Winston-Salem Southbound Railway. The freight station has been restored and is in use today as the Railroad Building, housing offices for Cassels. Caywood.Love, The Edmunds Group, J. S. Walker and Company, Putt-Putt, LLC, and a restaurant called Winston's Eatery.

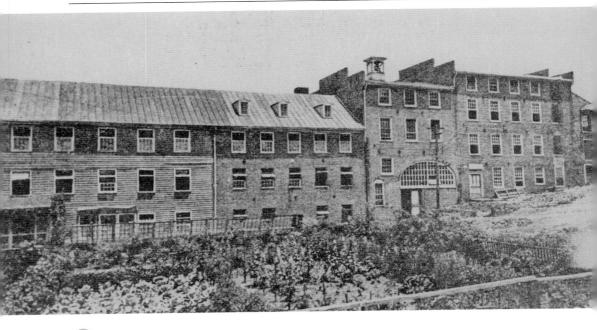

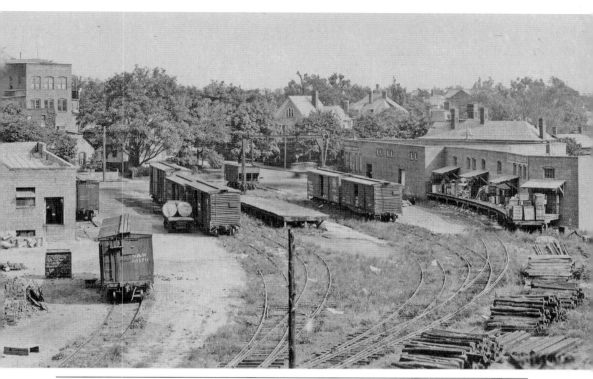

Next to the Winston-Salem Southbound Railway freight yards in 1928, the back (above, at right) of a wholesale fruit and produce business called Froeber-Norfleet, Inc., could be seen. Another tenant in the same building, named Gray and Creech, was concerned with wholesale paper, school supplies, toys, and paper bags. Both businesses took advantage of their proximity to the freight rails to receive shipments to restock their shelves. The Children's Museum opened in 2004 at this location, founded by the Winston-Salem Junior League.

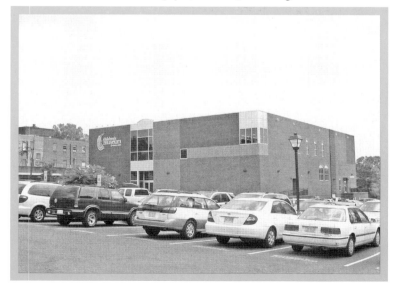

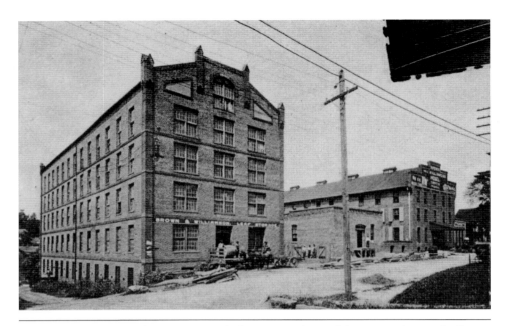

Brown and Williamson Tobacco Company built its factories at 104–118 North Liberty Street. The company was founded by T. F. Williamson and George Brown and incorporated in 1906, the date of this photograph. Brown and Williamson purchased the J. G. Flynt Tobacco Company in 1925 and moved the company's general offices to Louisville, Kentucky, in 1929. Corpening Plaza was built on this site in 1987, named for Wayne Corpening, Winston-Salem's mayor from 1977 to 1989.

White weatherboarding on the simple frame house at 115 North Green Street belied its historical significance as the first schoolhouse in the town of Winston. Residents of the house knew that it was an old schoolhouse and could see evidence of logs that were hidden behind paneling and siding. Originally located at First and Liberty Streets, the schoolhouse was moved in 1985 to the Village of Yesteryear at the fairgrounds to continue educating residents about Winston's early days.

The 400 block of North Main Street was fully occupied by large and small businesses when this photograph was taken in the 1940s. The Reynolds Building is shown at right, and other businesses on the block included cafés, locksmiths, billiard parlors, a garage, and the Forsyth County Jail.

The Reynolds Building still occupies the corner at right, adjacent to the tall Reynolds American Plaza Building. The One West Fourth Street building is on the corner at left, with a parking deck occupying the remainder of the block.

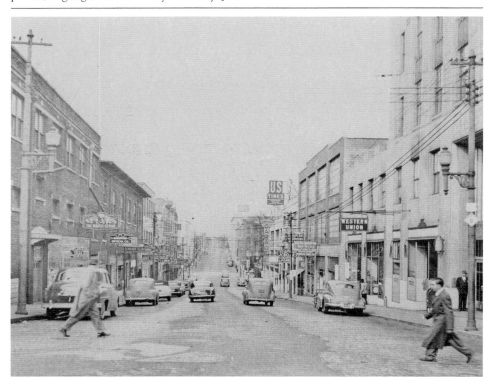

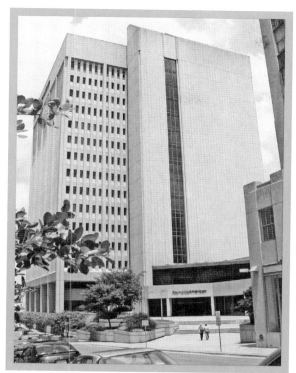

Winston's first tobacco sale took place in 1872 in a makeshift warehouse on Liberty Street. Maj. T. J. Brown was the force behind the early tobacco business, and in 1884, he formed a partnership with W. B. Carter and built a new tobacco warehouse (below) in the 400 block of North Main Street. Brown's Tobacco Warehouse was replaced in 1926 by the Downtown Garage. In 1982, the 16-story Reynolds Plaza was built adjoining the Reynolds Building, reclaiming the block for the tobacco industry.

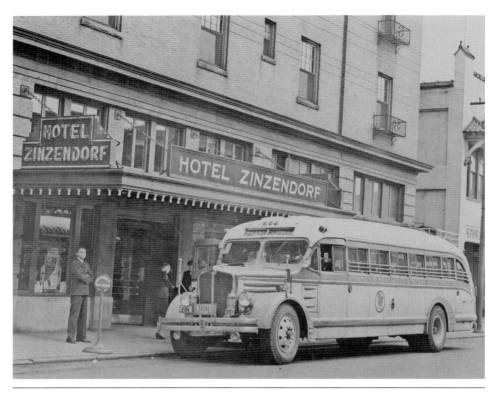

Hotel Zinzendorf opened on Main Street in 1906 on the site of the former Jones Hotel, which was previously the Merchants Hotel. The city's first bus station was located next door, and the hotel provided rooms for travelers and boarders, plus some businesses, until it was demolished in 1971. The Federal Building was opened in 1976 on the Hotel Zinzendorf site in the 200 block of North Main Street. The building was named for federal judge Hiram H. Ward in 1999.

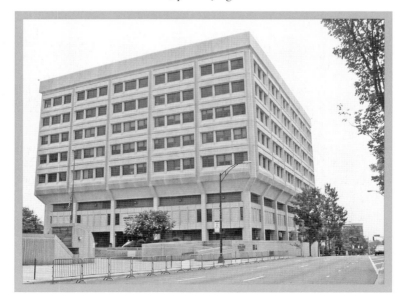

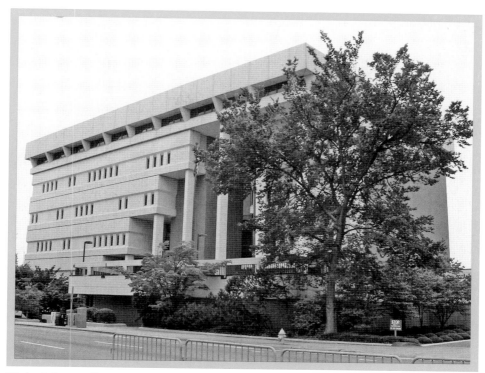

Wachovia Loan and Trust Company was located in the middle of the 200 block of North Main Street. In 1911, this business merged with Wachovia National Bank and moved into a building at the corner of Main and Third Streets. In 1971, the block of buildings from Second Street up to the 1911 Wachovia Building on the corner was demolished. The Hall of Justice opened in 1974 on this site, marking the first time since 1850 that the seat of Forsyth County government had permanently moved away from the courthouse square.

Alexander Christopher Vogler purchased a lot at the first land sale in the town of Winston. Trained as a cabinetmaker, he established his furniture business on this lot at Main Street near First Street in 1858. A few years later, Vogler added undertaking to his business, which already included the construction and sale of coffins. The Vogler family continues to operate the funeral home business at the original location but under the new name of Salem Funeral and Cremations.

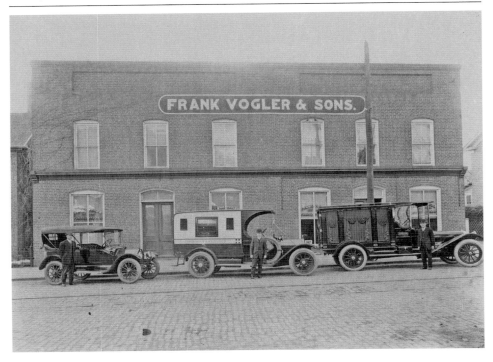

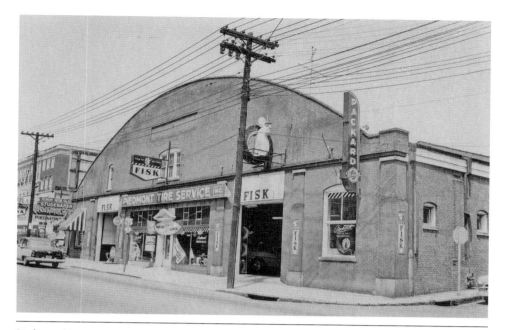

Piedmont Tire Service occupied the building at 121 South Main Street, in the shadow of city hall, in 1956. In earlier days, the structure with the domed ceiling housed Universal Auto Company, where automobiles were sold and serviced. The block was later cleared and used as a parking lot.

The Wingate Inn was built beside Interstate 40, followed by City Hall South on the southeast corner of Main and First Streets. City Hall South was named the Bryce A. Stuart Municipal Building in 2006.

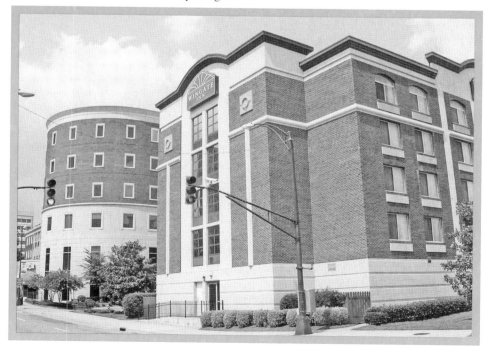

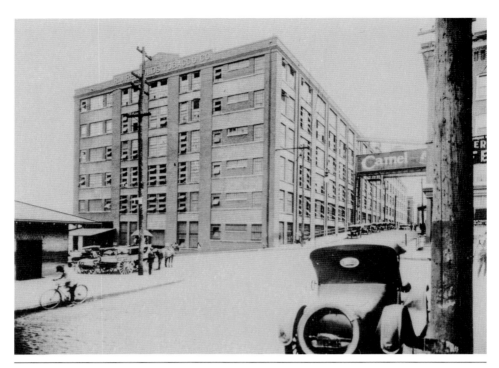

R. J. Reynolds had a practice of numbering his tobacco manufacturing buildings. Factory No. 12 was constructed in 1916 on the southwest corner of East Third and North Chestnut Streets. After many of the manufacturing operations moved away from downtown to Whitaker Park and Tobaccoville, Factory No. 12 became the last Reynolds Tobacco factory operating in downtown Winston-Salem. The factory closed in 1990 and underwent extensive remodeling to reopen in 2003 as the Forsyth County Government Center.

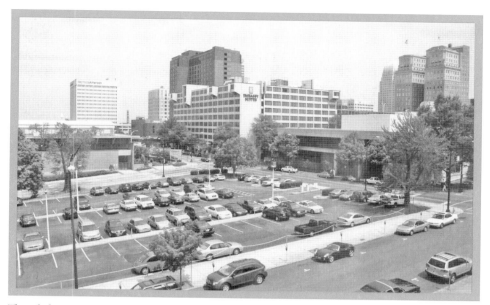

The skyline, as seen from the First Baptist Church on West Fifth Street, reflects the changes that have taken place over the 35 years between photographs. This view of the Robert E. Lee Hotel was captured shortly before its implosion in 1972. For over 50 years, the hotel witnessed the social and physical changes of a growing city. The Robert E. Lee Hotel was replaced by the Hyatt Regency Hotel, which is today the Embassy Suites Hotel. (Now photograph by John H. Grogan.)

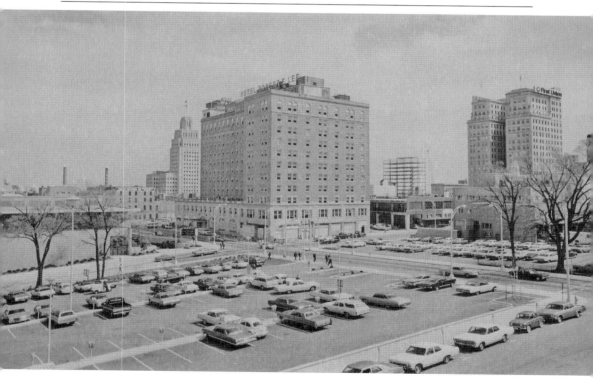

The Salem Manufacturing Company complex on Brookstown Avenue at South Marshall Street was the site of an early cotton mill. The triangular building at center was the power plant for the mill. Restaurants and small shops have occupied the mill buildings over the years. The Winston-Salem Visitor Center and the Brookstown Inn currently reside in the former mill complex (above, at left). Tar Branch Towers (above, at right), with the Meridian Restaurant on the street level, was built in 2007 in a matching architectural style.

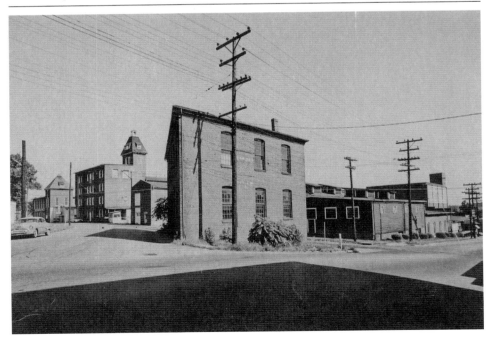

Forsyth County's jail moved around over the years. In 1908, a brick jail was built in the 400 block of North Main Street, but by 1936, it needed renovations. The jail relocated to the third floor of city hall until a new jail (shown in the photograph) was built in 1952 behind city hall. The 11-story Forsyth County Detention Center was built one block north in 1995, at 201 North Church Street, on a former tobacco factory site.

The Old Salem restoration drew visitors from the very beginning, so a visitor center was established in 1952 in leased space on Main Street. A new visitor center (above) was built in 1964 behind the Single Brothers House with more room for reception and exhibit areas. This building and parking lot were demolished when a new visitor center was constructed in 2003 on Old Salem Road. A terraced garden, restored to its 1770s look, was planted in its place. In 2006, Old Salem received a prestigious landscape-preservation award for its restored garden.

South Main Street was a busy thoroughfare in 1956, before the Salem Bypass (Old Salem Road) diverted daily traffic around the restored town of Old Salem. Some of the buildings shown in the 1956 photograph of the 500 block of South Main Street are Welfare's Drug Store, Krispy Kreme doughnut store, Salem Station Post Office, and Tom Perry's Grill. The street today is occupied by restored houses that depict how the Moravians in Salem lived and worked in the 18th and 19th centuries.

Nothing makes one long for the "good old days" more than a sign advertising gasoline for 28¢ a gallon. Gasoline stations, grocery stores, and other businesses thrived along this stretch of South Main Street at one time. After a period of declining business and vacated buildings, new construction and new life are coming to the Southeast Gateway area. One newly completed building, the Gateway YWCA, opened in June 2007 and is shown at right in the photograph above.

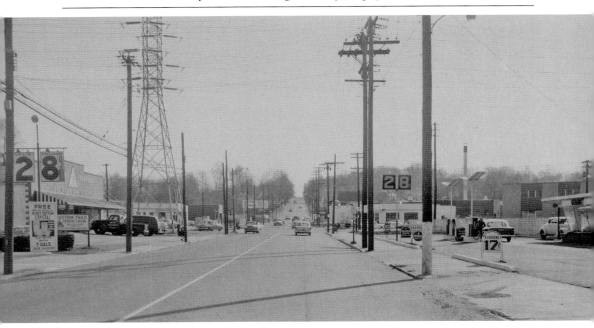

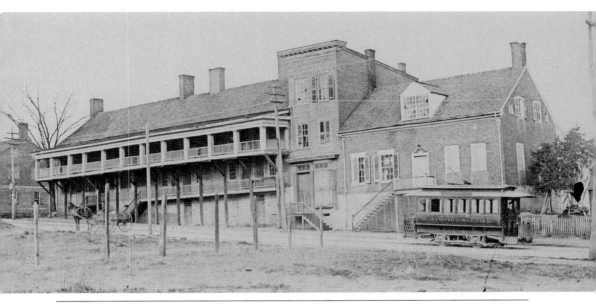

The 800 block of South Main Street exhibits several architectural styles in this 1890s photograph. David Blum built the large house at left in 1844 and sold it to Dr. Augustus Zevely, who operated a guesthouse. The house was restored in 1994 and is today the Zevely Inn (brick house shown below at left). Traugott Leinbach built his combination home and silversmith shop, at right, in 1824. The three-story house addition (above) was built in the 1850s. The original house and the addition were demolished, and the house was reconstructed in 1975 (below, at right).

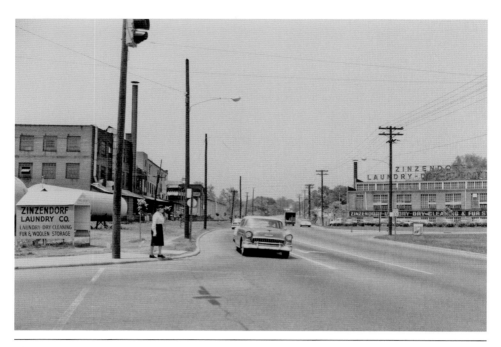

The Zinzendorf Laundry was established in 1906, in connection with the Zinzendorf Hotel. The laundry expanded its services and facilities over the years to meet business demands. The laundry (above, at right) moved to 1000 South Main Street about 1923 and is shown in a 1962 photograph.

The building was purchased by Old Salem and demolished in 1976. Trees planted along the Old Salem Road today form a buffer for the historic community, and the suspended covered bridge carries visitors to and from the Old Salem Visitor's Center.

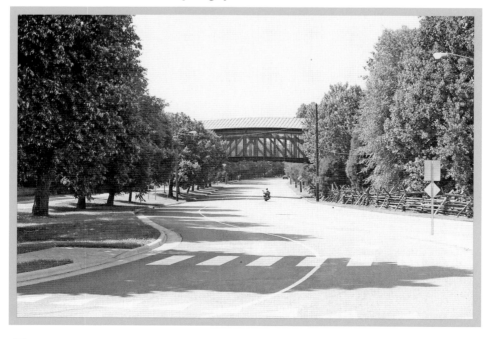

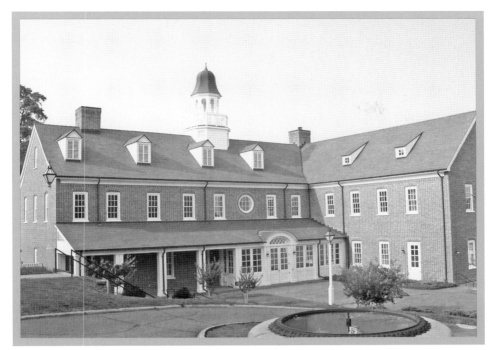

The brick archives building at 4 East Bank Street was originally the land office for the Moravian community. Dr. Adelaide L. Fries was the first archivist in the Southern Province and is credited for gathering church records and for beginning the publication of *Records of the Moravians in North Carolina*. In 2001, a new home for the Moravian Archives and the Moravian Music Foundation was built near the Moravian graveyard and was named the Archie K. Davis Center.

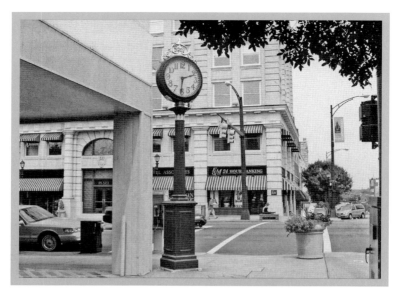

"Meet me at the clock" was a frequent arrangement for downtowners in the first half of the 20th century. The clock was a familiar landmark that was installed in 1914 on Trade Street to advertise Fred N. Day's jewelry store. The laws regarding blocking the sidewalks made it illegal to move the clock down the street when the business relocated in 1954. David Day sold the clock to a friend in Salisbury, where today it keeps their townspeople on time for work and appointments.

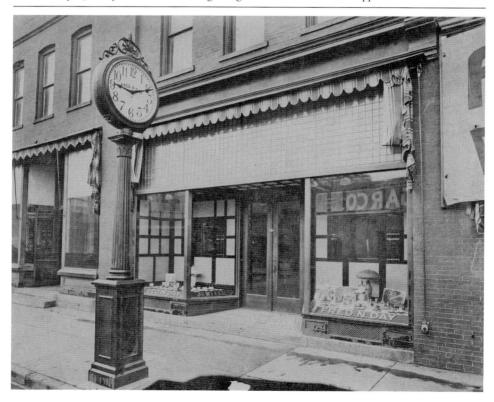

CRUISING STRATFORD ROAD

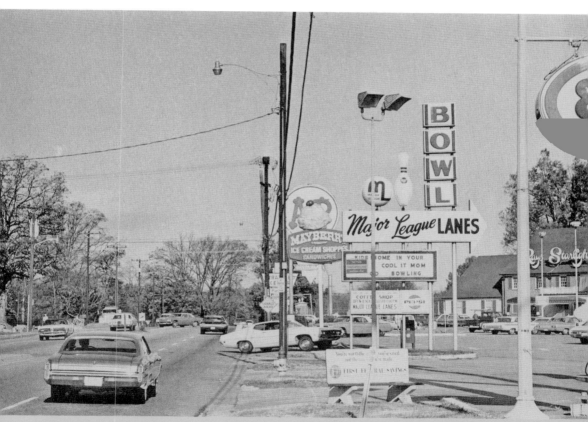

In earlier days, Stratford Road was known as the Clemmons Highway, because its primary purpose was to take travelers to Clemmons. When Thruway Shopping Center opened in 1955, Stratford Road became very attractive to many businesses, including those whose signs can be seen in this 1971 photograph. Some of these were Mayberry's Ice Cream Shoppe, Major League Bowling Lanes, A&P grocery store, and Ray's Starlight Restaurant.

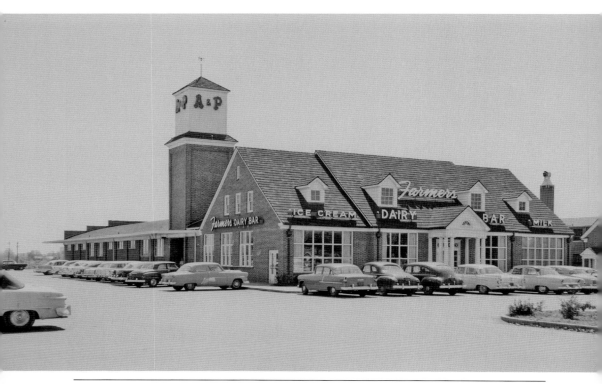

Farmer's Dairy Bar opened on Stratford Road in 1954 in a two-story, Colonial-style building. The floors were made of terrazzo tile and lighting in the building assured a "bright as day" appearance. The wallpaper in the private party room, called the Colonial Room, featured scenes from the Orton Plantation in Wilmington. Mayberry's Ice Cream Shoppe later filled this location until it moved to Miller Street and the building was demolished. Locally-owned Big Shotz Tavern occupies this location today.

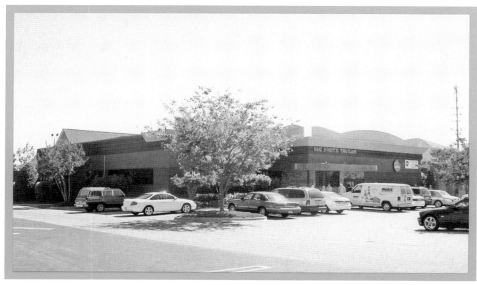

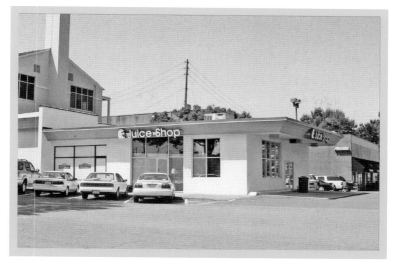

City National Bank began its existence as a bank in 1917 as the Winston-Salem Morris Plan Company. The name changed to City National Bank in 1940, when it became a nationally chartered commercial bank. For many years the main offices were located at 206 West Fourth Street. In 1955, the bank opened its third branch at the Thruway Shopping Center, shown in the photograph. Today the Juice Shop occupies the bank branch site, dispensing a variety of tasty fruit smoothies.

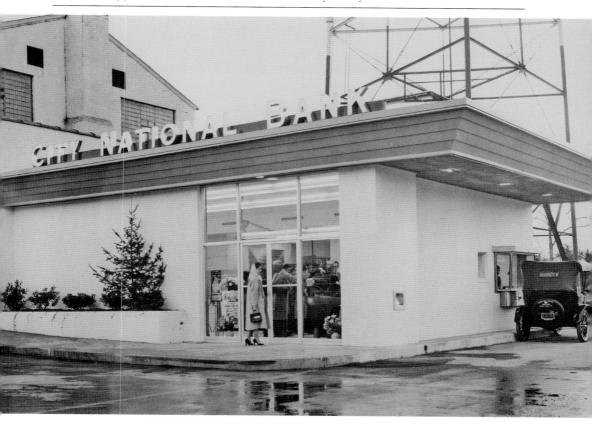

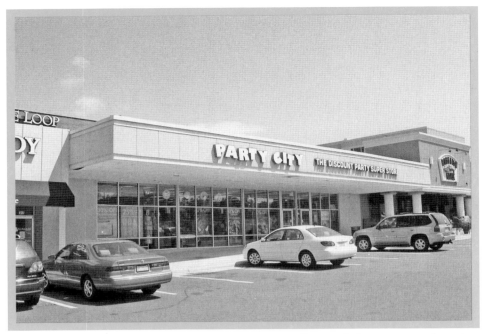

Thruway Theatre opened in grand style in February 1969 next to Town Steak House on Stratford Road. Steve McQueen starred in the detective thriller *Bullitt*, while the audience enjoyed continental seating in the first rocking-chair theater in Winston-Salem, with an Ultra-Vision projection system, all-new plush carpets, and modern furniture. The only visible reminder of the theater today is the time capsule plaque on the sidewalk in front of Party City, one of the current occupants of the previous theater space.

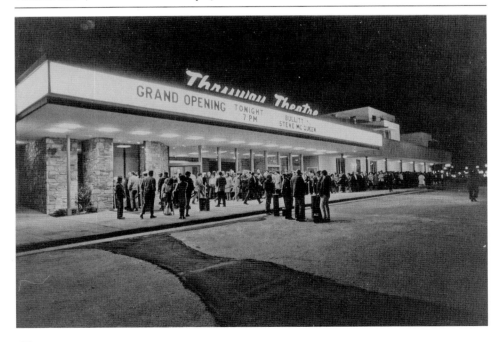

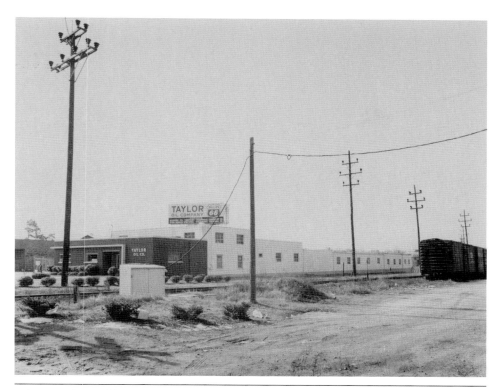

Roby E. Taylor established Taylor Oil Company in 1946 as a wholesaler of petroleum products in Winston-Salem and the surrounding area. The corporation moved into its new office and plant on a 2-acre tract on Oakwood Drive off Stratford Road in 1946. The Taylor Oil complex and several neighboring businesses were demolished to make way for a five-story office building called 110 Oakwood. As one of several tenants in the building, Taylor Oil maintains its seniority status at this location.

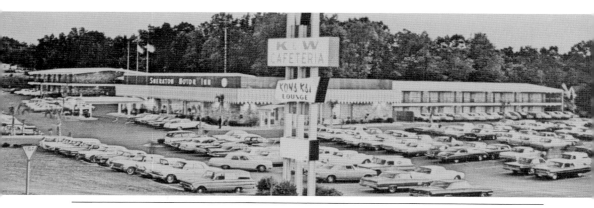

The Sheraton Motor Inn, built in 1964 at the southwestern corner of Interstate 40 and Knollwood Street, offered the traveler more than overnight accommodations. With 122 bedroom units, the inn featured a 315-seat K&W Cafeteria and the Hawaiian-themed Kona-Kai Lounge. Palmetto trees surrounded the motel, and a swimming pool and putting greens provided entertainment for the guests. An explosion leveled the motel in the 1980s, and today a variety of tenants occupy the 380 Knollwood Street buildings.

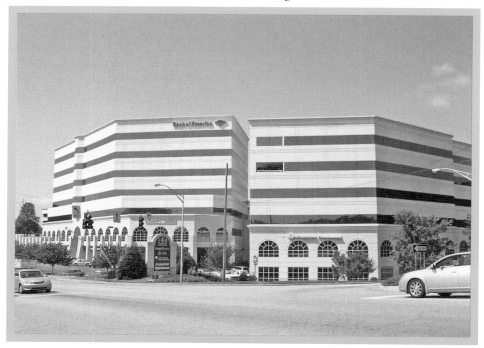

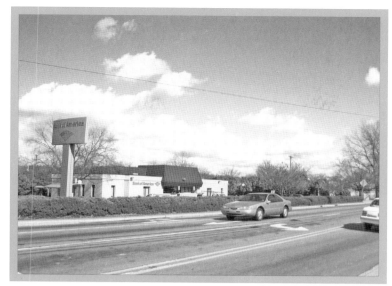

Lawrence Staley purchased a former filling-station-turned-restaurant on the corner of Stratford Road and Knollwood Street in 1951. The eatery (shown below) was a popular gathering place for young people and featured a jukebox, pinball machines, and curb service, with a large floor area for dancing.

A new, modern Staley's restaurant was built here in 1963 behind the wooden building, which was then demolished. Staley's Stratford Restaurant eventually gave way to a Bank of America branch. (Then image courtesy of Quality Oil Company.)

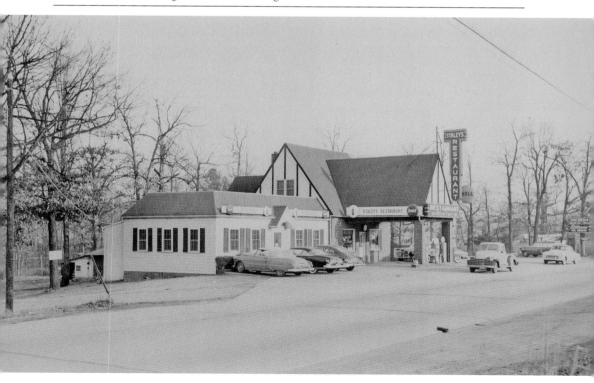

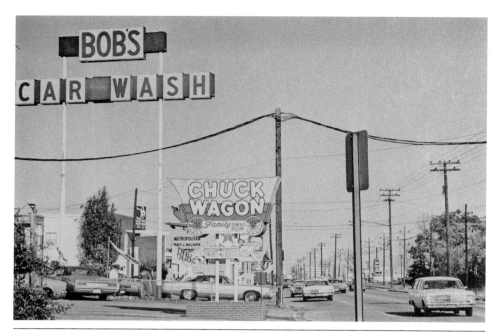

The Chuck Wagon Restaurant opened on Stratford Road in 1964, following the burning of the popular Castle Drive-in and the loss of drive-in service at the new Staley's Stratford Restaurant. The Chuck Wagon offered both sit-down and drive-in service and was a popular weekend cruising destination. The restaurant relocated to the Old Town community in the 1970s and closed in 2004. A new Chuck Wagon Restaurant, complete with Western decor, opened in the Old Town Shopping Center in 2007.

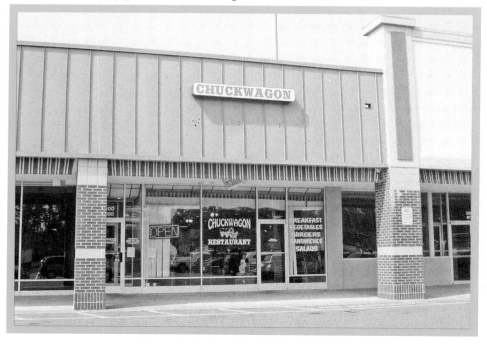

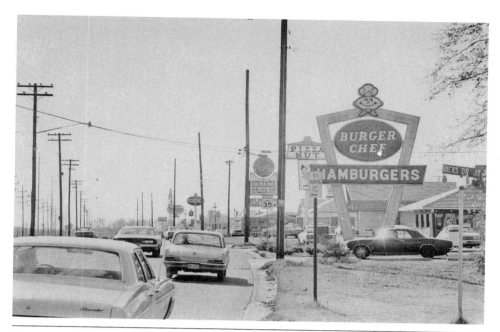

The 1971 view of Stratford Road from Ricks Drive, with the photograph looking the opposite direction on the previous page, makes a good comparison of the businesses along this stretch of the road. More development can be seen today on the left-hand side of the road, while the right-hand side reflects changes in the individual businesses. Burger Chef and Bonanza are absent from the city today, while Pizza Hut has relocated on Stratford Road. Ham's Restaurant (below, at right) recently closed, demonstrating the fluid nature of the restaurant business.

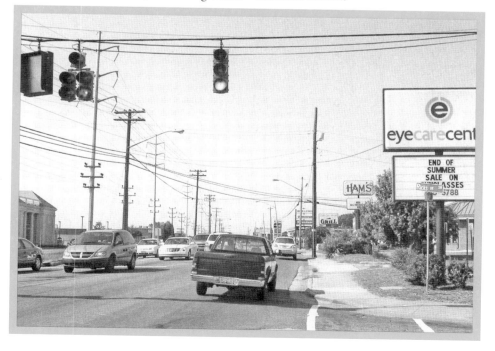

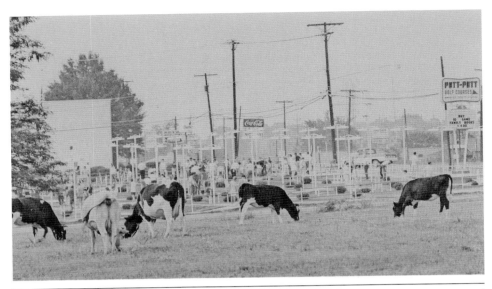

One doesn't see many cows along Stratford Road near Hanes Mall these days, but before the mall claimed the farmland along Stratford Road, cows lived a quiet existence beside the Putt-Putt Golf Course. The Putt-Putt facility offered three courses for sharpening the putting technique and later added a building with refreshments and coin-operated games. A giraffe stands tall over the Adventure Landing courses today, where golfers can putt through caves with waterfalls spilling over the rocks.

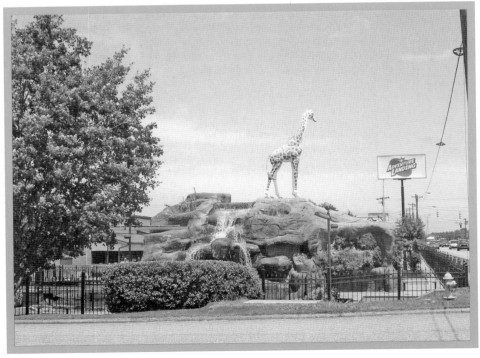

CHAPTER 3

MOTORING
REYNOLDA ROAD

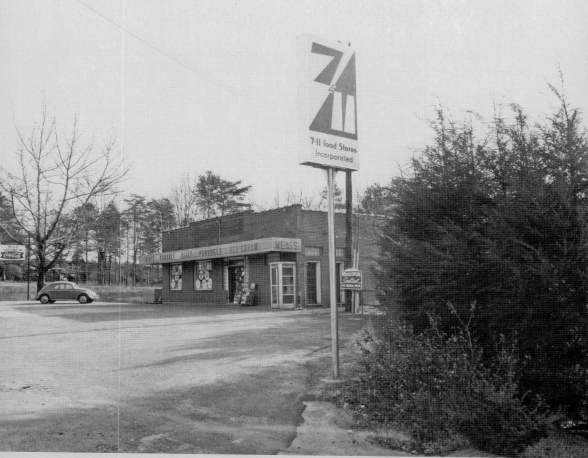

Jim Gilley and Tom Preston opened the first of their 7-11 food stores in 1961 at 3132 Reynolda Road in a remodeled building. By 1963, there were five units open, all constructed after a model that sported sliding glass panels across the front of a one-story brick building 80 feet wide and 40 feet deep. Today Color Carpets occupies the former 7-11 store.

Ammons Esso Servicecenter was a fixture at 1200 Reynolda Road for 30 years under the ownership of Lenwood Ammons. The station changed hands in 1979 and has housed several businesses over the years. Rebecca and Company, a ladies' boutique, occupies this location today. Next door in the 1959 photograph is the Robin Hood Curb Market, and later the Buena Vista Garden Shop was located here. The larger, brick building, home today to McGill Realty and other businesses, was constructed in front of the garden shop.

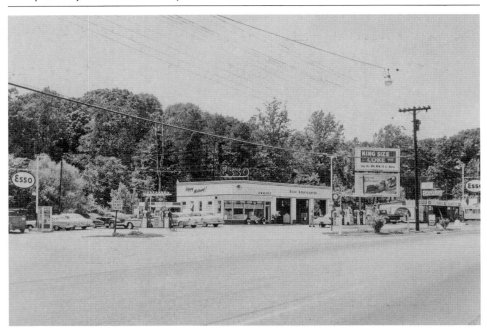

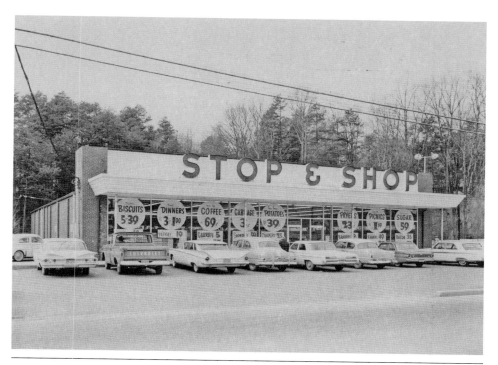

Stop and Shop opened in 1959 at 1214 Reynolda Road. The store's motto was "Nobody, But Nobody, Undersells Stop and Shop." Opening the supermarket was the first venture in the grocery business for Jim Gilley, although he had previous work experience in the industry. The Reynolda Road store, plus two other Stop and Stop stores and a supermarket called the Market Basket, were purchased by Big Bear in 1966. The building today is occupied by Buena Vista Eye, Hair Quintessence, and If It's Paper.

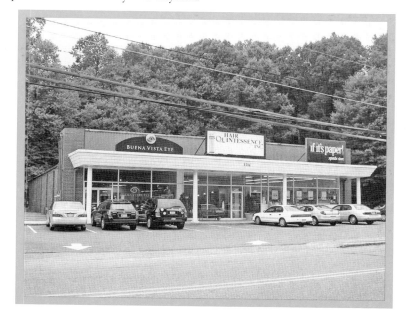

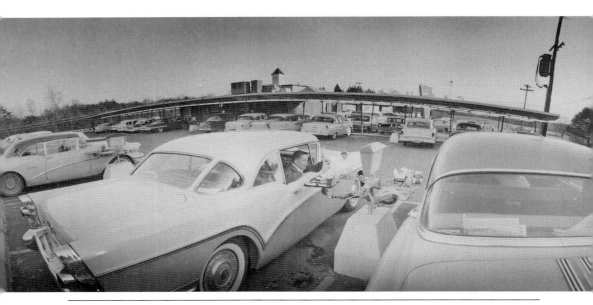

Lawrence Staley and Quality Oil Company teamed up to build a combination restaurant/filling station at Reynolda and Oldtown Roads in 1937. Staley's early building was replaced in 1959 with a drive-in restaurant with 50 teletray spaces where diners could order from their cars. A new Shell service station was built in front of the drive-in restaurant. Today a Quality Mart and a SunTrust bank branch share the former restaurant and service station location at Reynolda Road and the renamed Fairlawn Drive.

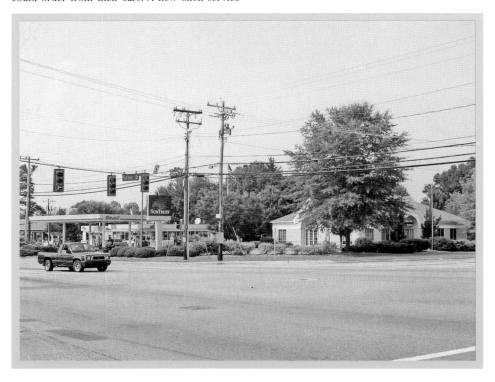

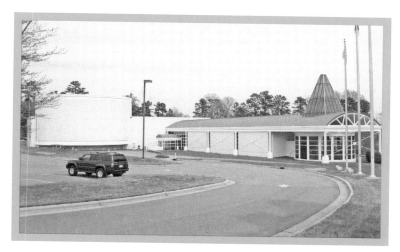

The Nature Science Center was founded in 1964, with its first home in rented space at Reynolda Village (below). As the museum grew, so did the need for more lecture and workshop space, a larger planetarium, and more space to expand the physical sciences program. The center moved in 1972 to the former Forsyth Home facilities on Hanes Mill Road. A new building was constructed on this site in 1992, with further expansion in 2002. Today the Science Center and Environmental Park of Forsyth County is known as Sciworks.

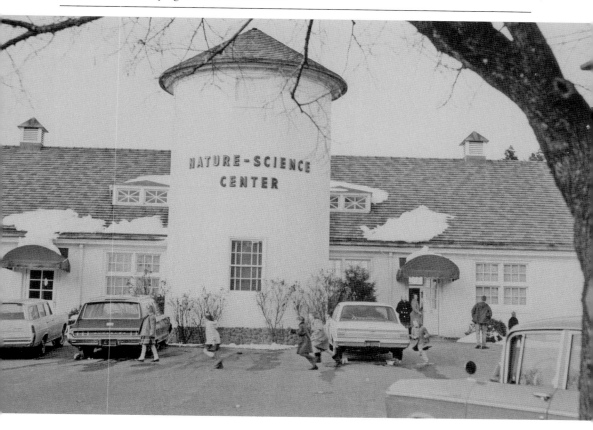

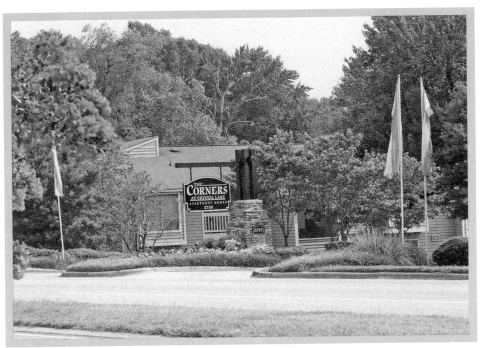

Richard Davis bought an 80-acre farm on Reynolda Road in 1915. In addition to farming, he established a brick kiln, selling most of the brick to R. J. Reynolds for his new home, Reynolda. Davis dammed a stream near the brickyard and made a lake for harvesting ice during the winter. This was the beginning of Crystal Lake, a privately owned public swimming lake and park that operated from 1922 to 1975. Today the Corners Apartments are located on the site.

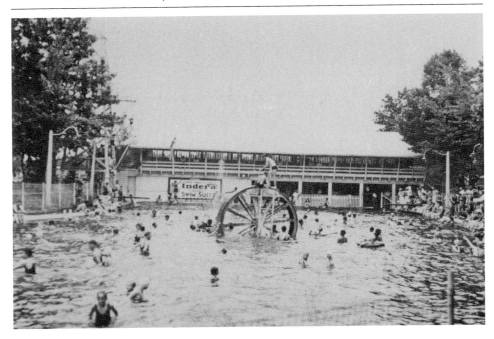

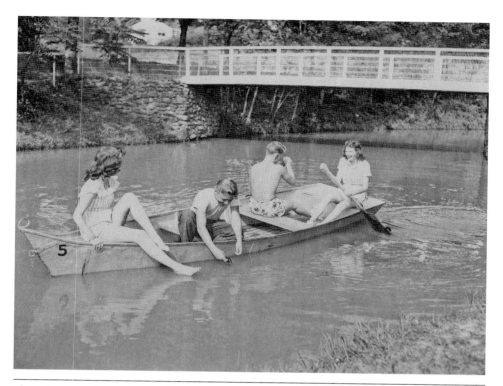

Above the swimming pool and bathhouse/pavilion at Crystal Lake was a boating lake. Situated in the boating lake was an island with a picnic pavilion, attached to the nearby land by a bridge. Boats could be rented for a ride around the island or to carry a picnic to the pavilion. The bridge, picnic shelter, and boating lake, surrounded by trees, exist today as part of the Corners Apartments complex.

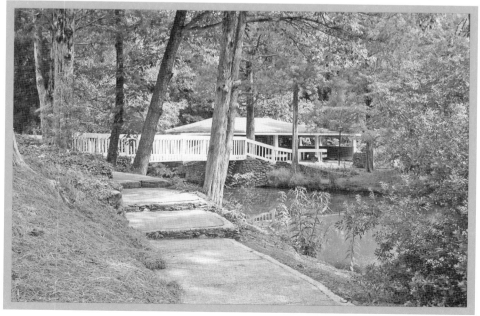

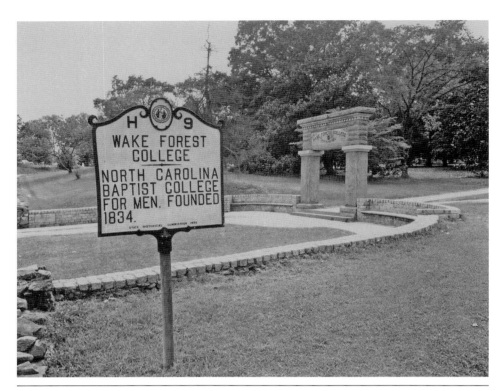

Wake Forest College's class of 1909 presented an engraved stone arch as its gift to the school. The arch stands today in Wake Forest, North Carolina, near U.S. Highway 1. Wake Forest College moved to Winston-Salem in 1956. The class of 2006 commissioned an identical concrete arch in celebration of the 50th anniversary of the move. The arch was erected on the campus at the entrance to Hearn Plaza, named in honor of Thomas K. Hearn Jr., retired Wake Forest University president.

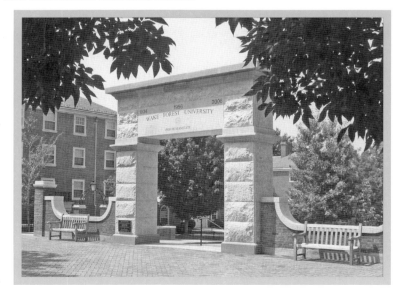

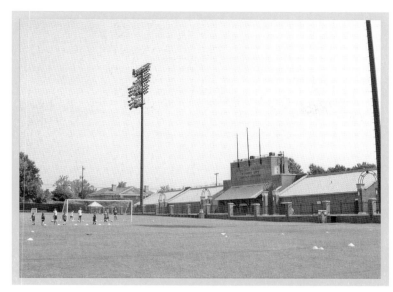

A sign announcing a meeting before the Zoning Board of Adjustment is placed at the Polo Road edge of the proposed Wake Forest campus in 1951. Lorna Larson, daughter of architect Jens Larson, watches E. J. Brewer (left) and Gaston Shortt Jr. plant the sign. In 1996, the W. Dennie Spry Stadium became the home for Demon Deacon soccer. Today Polo Road is a paved thoroughfare bringing students, players, and spectators to the manicured fields for soccer games and summer camps.

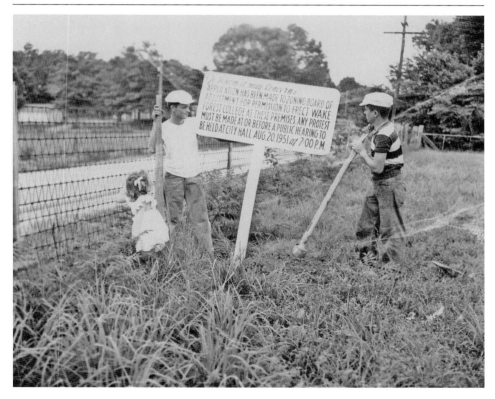

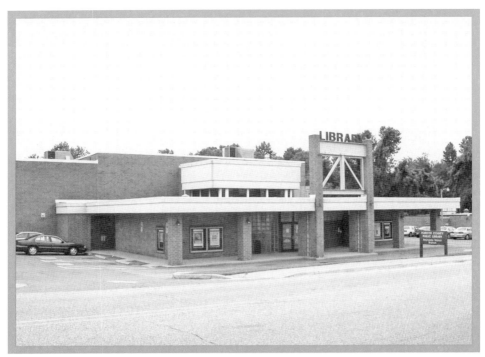

Jane Fonda, Jason Robards, and Dean Jones came to town in a 1967 movie to introduce the city's newest theatre, the Reynolda Cinema. Jane, Jason, and Dean starred in the movie *Any Wednesday*, which showed five times daily, with adults admitted for $1. Reynolda Cinema, located on Fairlawn Drive, was later divided into three theaters before it closed in the 1990s. In 1998, the Reynolda Manor branch library moved from a smaller building two doors away into the renovated theater space.

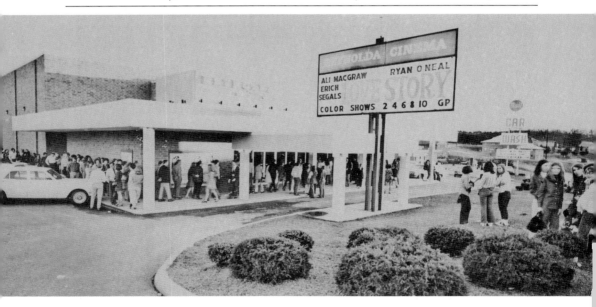

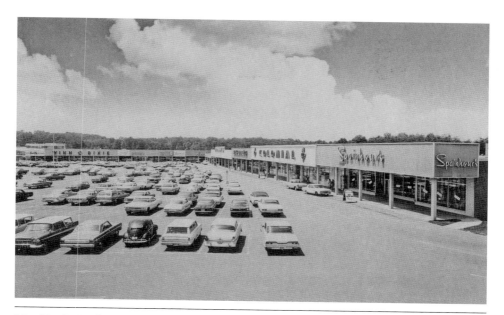

Miss North Carolina Janice Barron clipped the green ribbon to officially open Reynolda Manor Shopping Center in March 1963. Among the 22 businesses that composed the center were Spainhour's, Colonial Store, Arcade Fashion Shop, Hinkle's Book Store, Eckerd's Drugs, Bud Smith's Flowers, and W. T. Grant Company. Two of the original stores, Camel City Laundry and Dewey's Bakery, exist today among the many new tenants in the expanding shopping center on Reynolda Road. (Then photograph by Gordon H. Schenck Jr.; Now photograph by John H. Grogan.)

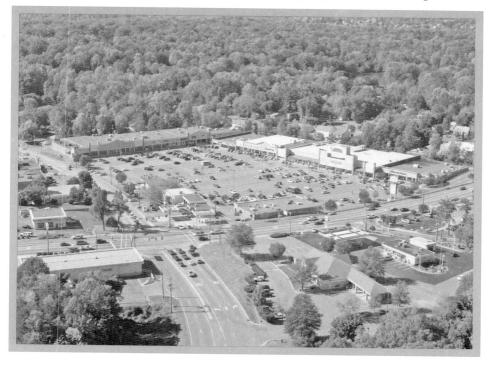

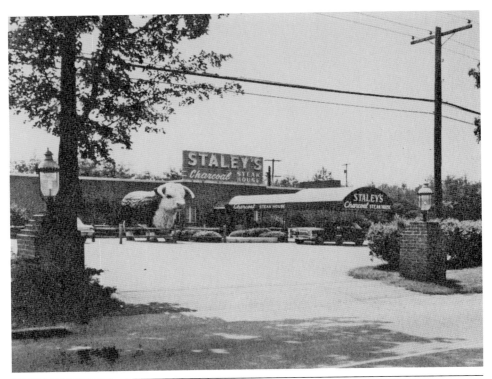

Lawrence Staley and Kenneth Cheek opened Staley's Charcoal Steak House at 2000 Reynolda Road in 1957. The restaurant was known for its steaks, potatoes, and salads, plus the appetizer plates that preceded each meal. The restaurant was also known for the 11-foot-tall, 21-foot-long fiberglass bull that stood guard beside the front entrance. Staley's Charcoal Steak House was sold in 1990, and the bull moved to Waughtown Street, where it keeps a lofty eye on nearby Thrift Way Meats (below, at left).

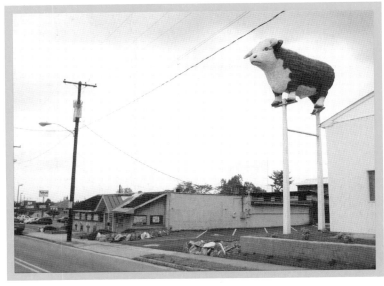

CHAPTER 4

TRAVERSING THE OUTSKIRTS

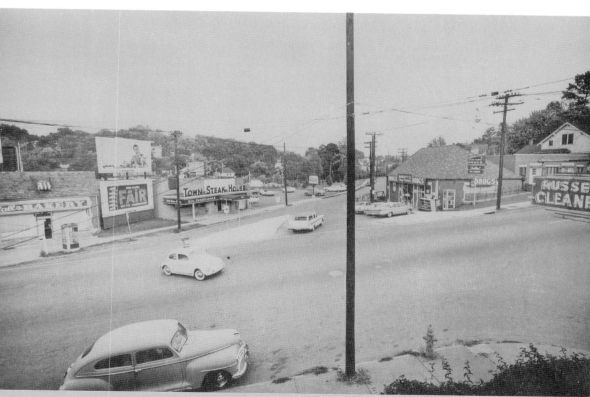

The name won't be found on a street map, but the area near Hawthorne Road, Lockland Avenue, and West First Street was called the "foot of the hill" among those who frequented the businesses in this area. Bobbitt's College Pharmacy, Town Steak House, Hall's Bakery, and the Ardmore Post Office were some of the businesses that made up the popular "foot of the hill."

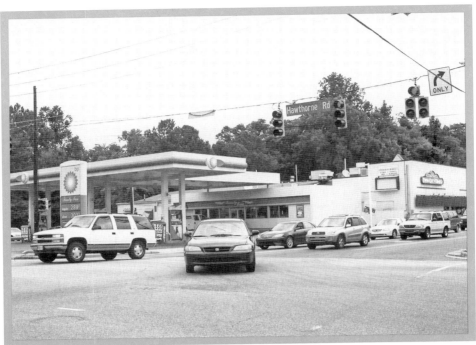

Gulf Super Service Station opened in 1942 at the corner of Hawthorne Road and West First Street. The station offered vehicle pick-up service, lubrication on the Rock-A-Car lift, Gulf No-Nox Gasoline, and Gulfpride Motor Oil. Visitors could count on free road maps, ice water, clean rest rooms, and many automotive necessities. The Family Fare BP station that occupies this location today also provides motorists with gasoline, maps, and water, plus many other conveniences. Twin City Diner can be seen at the far right.

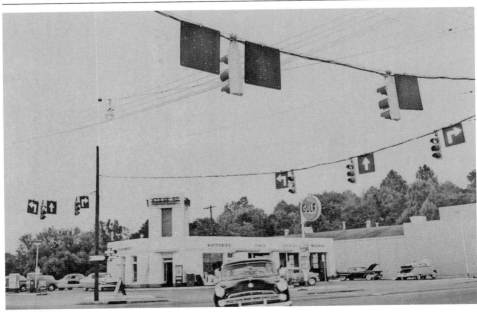

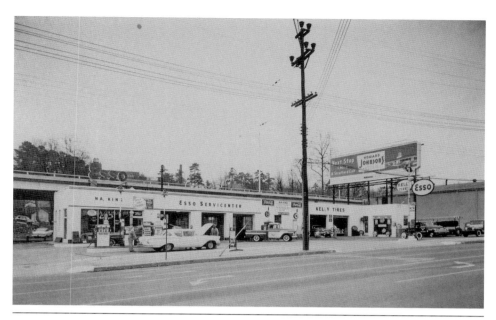

At one time, three of the four corners at First Street and Hawthorne Road were occupied by gasoline stations. N. A. (Numa Archie) King operated the Esso Servicecenter at 1510 West First Street, near Hawthorne Road. The business covered nearly the entire block, bordered by the A&P grocery store and a Pure service station and nestled under Interstate 40. Today the First Street Draft House occupies the corner of the block, with an expanding Baptist Hospital rising in the background.

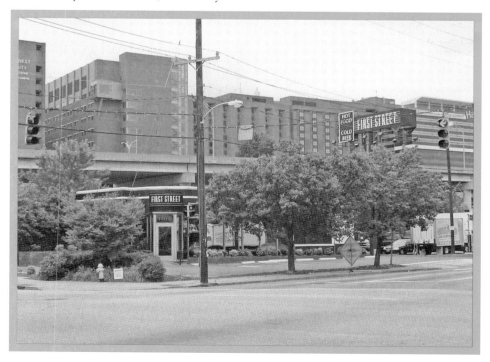

In the 1950s, the area called Cloverdale Hill, at Miller Street near Cloverdale Avenue, was owned by the city of Winston-Salem. Plans were announced to use this property for a civic and cultural center, complete with an auditorium and meeting rooms. These plans changed, and a shopping center and a Ford automobile dealership were built on opposite sides of Miller Street. The location proved to be popular, and today businesses fill the landscape around Cloverdale Hill, stretching from Stratford Road to Queen Street.

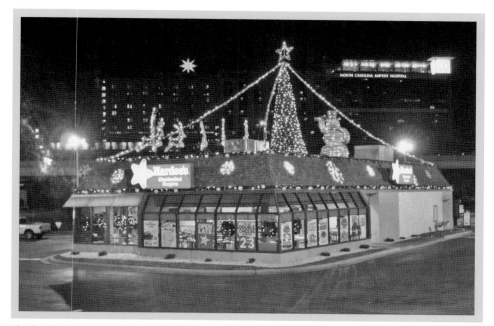

The lot bordered partially by Cloverdale Avenue and First Street was vacant for many years. When the Ardmore Post Office needed a new home, this plot of land was considered to be a perfect location, but the post office was built off Miller Street instead. Christmas trees were often sold here, so it was only fitting that when Hardee's built at this location, their rooftop Christmas display would attract attention from travelers passing by on Interstate 40 and from the patients in the nearby Baptist Hospital.

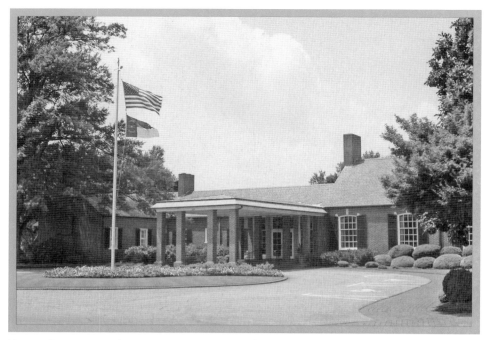

Miriam DuBose was the *Winston-Salem Journal* reporter who described the opening reception at Old Town Club in December 1939. She and a staff photographer were given a sneak preview of the club, and DuBose wrote a glowing review of the club's location and its furnishings. While the facilities have been enlarged over the years, one of the club's main attractions is the challenging 18-hole golf course designed by architect Perry Maxwell, who also designed the course at Reynolds Park.

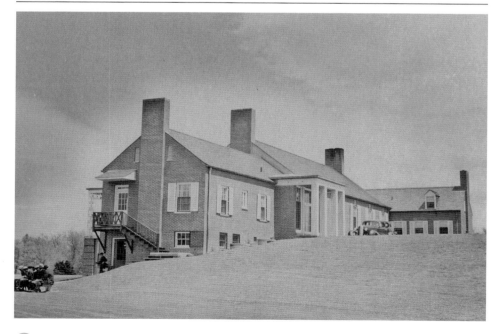

TRAVERSING THE OUTSKIRTS

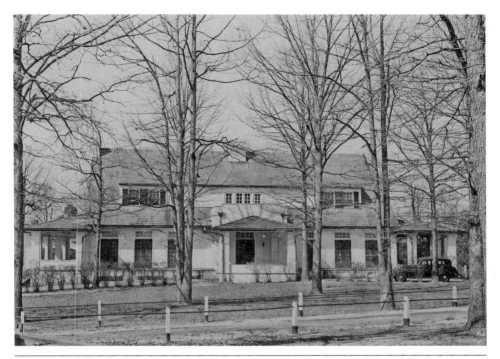

Forsyth Country Club has undergone many changes since it was constructed in 1915. The original design was a rustic look, and the layout featured a dining room, living room, ladies' parlor and dressing room, sleeping apartments, kitchen, and baths. An up-to-date water plant furnished water from two deep wells. The clubhouse is shown above as it looked in 1938, after an earlier expansion but before a major renovation in 1941. That first rustic clubhouse sits hidden within the walls of today's elegant and well-appointed facility on Country Club Road.

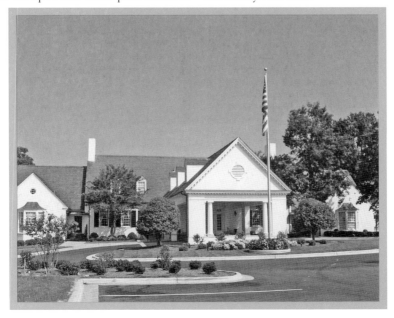

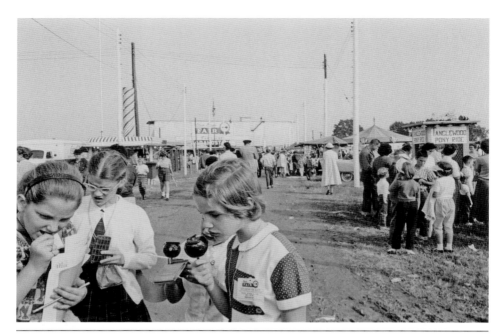

Fall and the Dixie Classic Fair are synonymous in Winston-Salem, for the fair has deep roots in the red Forsyth County soil. The year 2007 marked the 125th anniversary of the first agricultural fair in Winston. For many fairgoers, savoring the delicious aromas of fair food, examining the exhibits and animals, walking among the midway lights, and admiring the new attractions are annual events. One of the newer attractions, the clock tower, was constructed in 1995, lighting the sky above the fairgrounds.

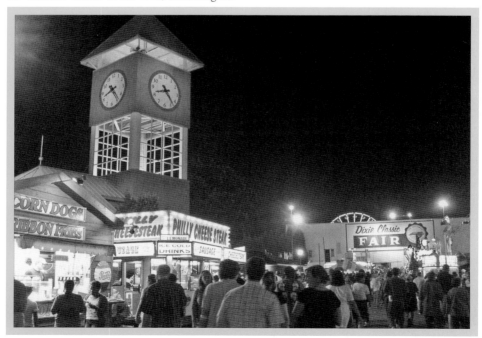

TRAVERSING THE OUTSKIRTS

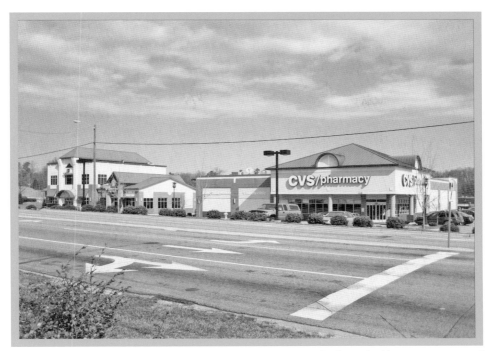

Many residents remember shopping at Mount Tabor Grocery Store on Robinhood Road. The independent grocery store's motto was "Low prices are born here and raised elsewhere." Originally located on Robinhood Road near the Polo Road intersection, the business gradually expanded until a larger building was constructed farther down the street, near the Peace Haven Road intersection. The popular store closed in 1994, and today CVS pharmacy, Starbucks coffee, and RBC Centura occupy the site at Mount Tabor Place. (Then photograph by the author.)

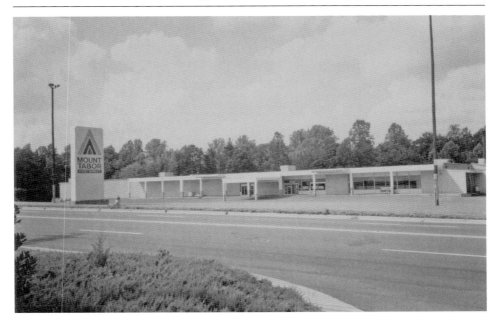

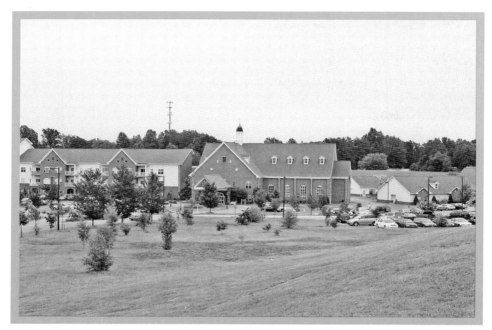

Salemtowne, the Moravian retirement community, traces its beginnings to 1887, when Salem Home was established by the Dorcas Circle, a local service league. The initial purpose of the home was to help women in need. A new Moravian Retirement Home for female and male residents opened in 1972 on Indiana Avenue. Cottage homes and apartments, plus a community and fitness center, were added over the years, and the name was changed to Salemtowne, with a new entrance off Bethabara Park Boulevard.

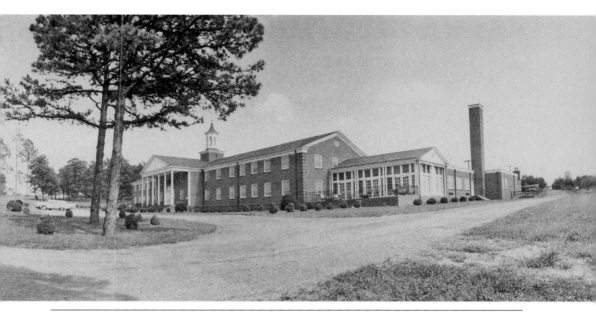

A Baptist Retirement Home opened in 1957 on Reynolds Park Road. In 1960, the home was named in honor of Rev. James M. Hayes, the first general superintendent of North Carolina Homes for the Aging. Apartments were added later to the Hayes Home campus to increase alternatives for independent living. A new Baptist facility called Brookridge Retirement Community opened in 1989. Located on 46 acres off Bethabara Road, Brookridge offers its 300 residents a variety of housing and service options.

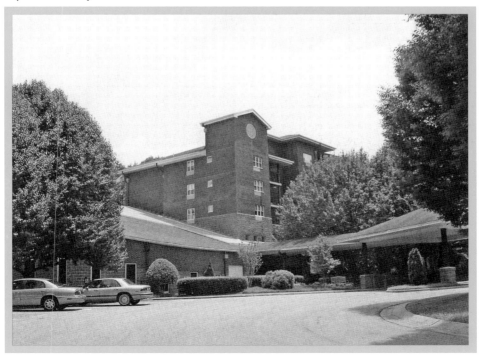

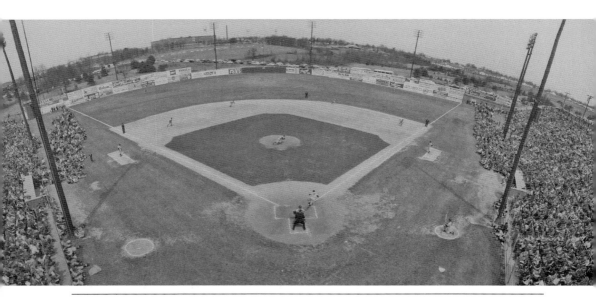

Ernie Shore Field, named for former Boston Red Sox pitcher and Forsyth County sheriff Ernie Shore, opened in 1956 on the corner of Shorefair Drive and Thirtieth Street. In 1958, an exhibition baseball game between the Philadelphia Phillies and the New York Yankees packed the stadium with fans of all ages. A new baseball stadium is under construction at this writing, but Ernie Shore Field will stay in the baseball business as the home for Wake Forest University's baseball team.

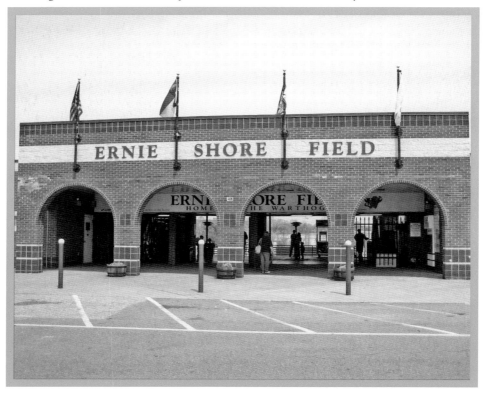

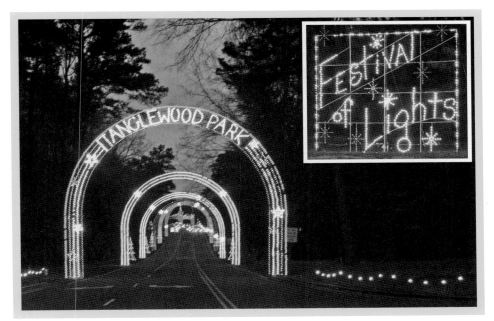

William Neal Reynolds and his wife, Kate Bitting Reynolds, lived at Tanglewood, off Highway 158, until their deaths in 1951 and 1946, respectively. The older photograph shows the entrance to Tanglewood in 1951, after the announcement that the Reynoldses willed Tanglewood to Forsyth County to be used as a park. In addition to golfing, swimming, camping, horse riding, boating, and picnicking, park visitors can enjoy the Festival of Lights, a spectacular holiday light display that enlivens the park landscape from Thanksgiving to New Year's.

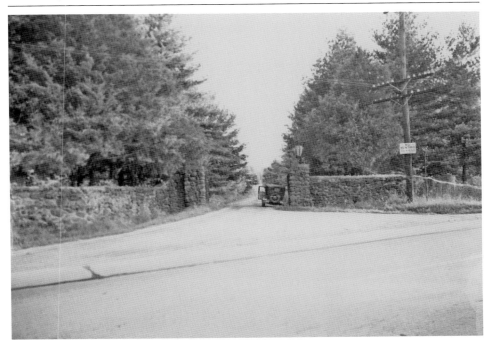

Many people have heard of Nissen Park, but few people living today actually visited the park in Waughtown. The 20-acre park opened in 1900, following the extension of the streetcar line to Waughtown, and was for many years the site for picnics, movies, roller-skating, botanical enjoyments, and swimming. Today all remnants of the park are gone, and residents of Billy Drive and Hill Lane may be unaware that their homes sit on one of the first recreational sites in Winston-Salem.

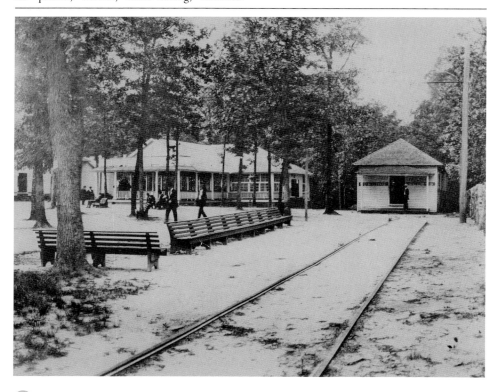

The author and her husband, Jeffrey, met when Molly was the corporate librarian at R. J. Reynolds Industries and Jeffrey was a mechanical engineer for R. J. Reynolds Tobacco Company. Molly and Jeffrey celebrate their 30th wedding anniversary in 2008 and are shown with their sons, Allen, Kevin, and Curtis. Molly is photo archivist for the Forsyth County Public Library and Jeffrey is general manager of International Tobacco Machinery USA. (Then photograph by Brenda Crisp; Family photograph courtesy of Bo's Photography.)

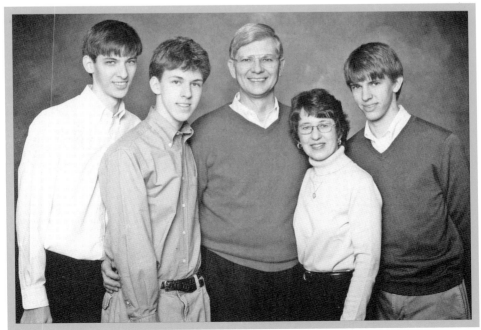

INDEX

ACROSS AMERICA, PEOPLE ARE DISCOVERING SOMETHING WONDERFUL. *THEIR HERITAGE.*

Arcadia Publishing is the leading local history publisher in the United States. With more than 3,000 titles in print and hundreds of new titles released every year, Arcadia has extensive specialized experience chronicling the history of communities and celebrating America's hidden stories, bringing to life the people, places, and events from the past. To discover the history of other communities across the nation, please visit:

www.arcadiapublishing.com

Customized search tools allow you to find regional history books about the town where you grew up, the cities where your friends and family live, the town where your parents met, or even that retirement spot you've been dreaming about.